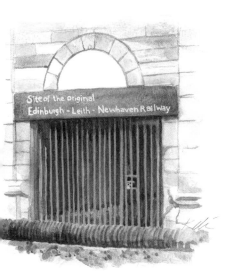

Site of the original
Edinburgh - Leith - Newhaven Railway

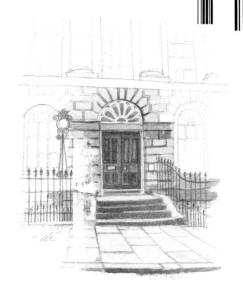

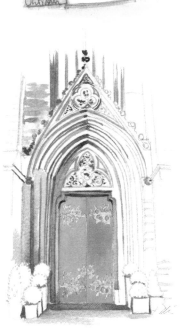

A
SKETCHBOOK OF
EDINBURGH

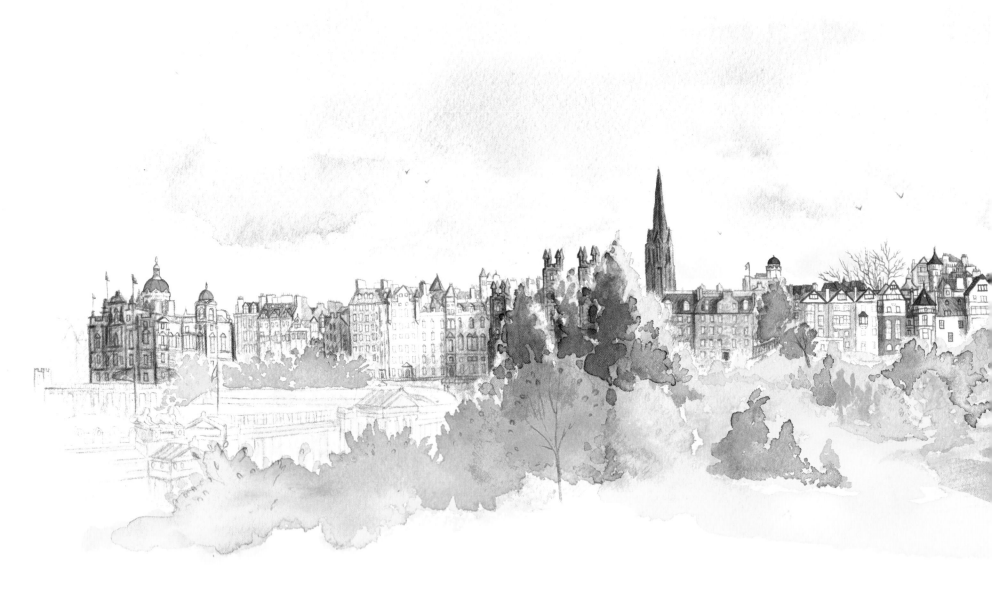

A *Sketchbook* of
EDINBURGH

IAIN FRASER AND ANNE FRASER SIM

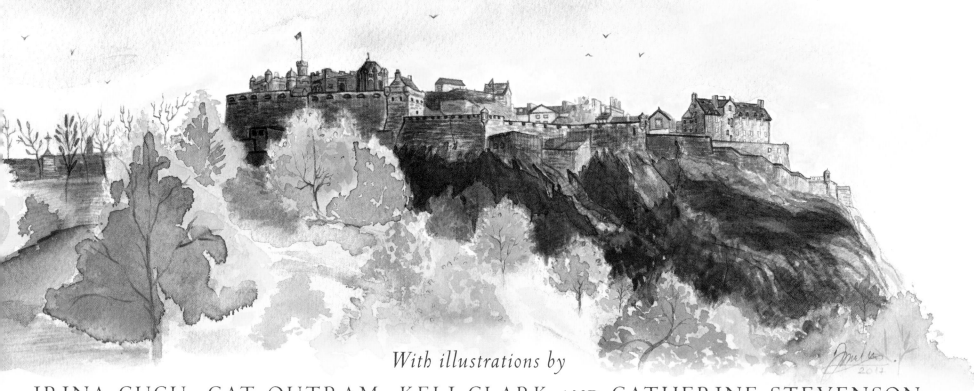

With illustrations by

IRINA CUCU, CAT OUTRAM, KELI CLARK AND CATHERINE STEVENSON

BIRLINN

In loving memory of David Sim

First published in Great Britain in 2017 by
Birlinn Ltd

West Newington House
10 Newington Road
Edinburgh
EH9 1QS

www.birlinn.co.uk

ISBN: 978 1 78027 487 4

British Library Cataloguing-in-Publication Data
A catalogue record for this book is available on request from the British Library

Illustrations by Irina Cucu, Cat Outram, Keli Clark and Catherine Stevenson
Designed by James Hutcheson
Layout design by Irina Cucu
Printed and bound in Latvia by Livonia Print

CONTENTS

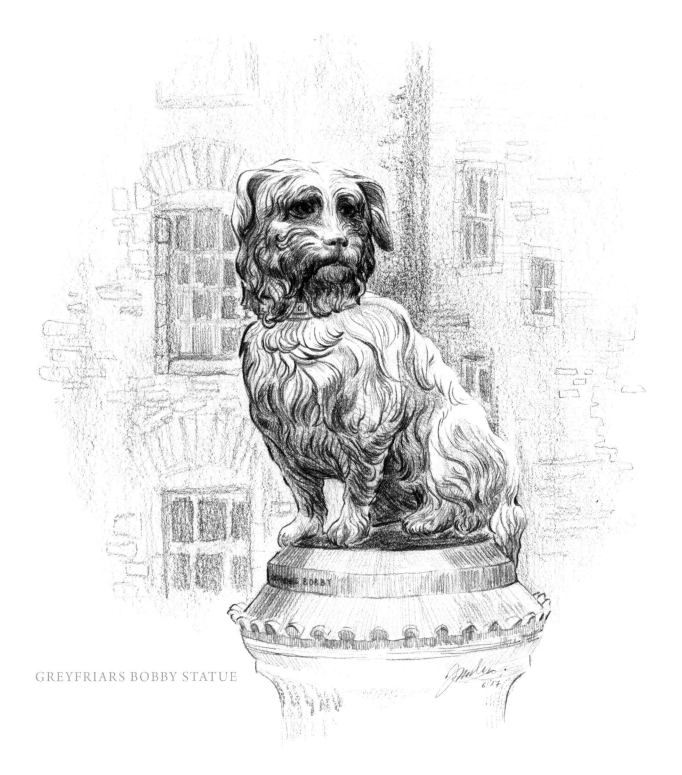

GREYFRIARS BOBBY STATUE

FOREWORD

Edinburgh is a city that is used to tributes, many of them glowing and most of them accurate. Yes, it is a city of heart-stopping sights; yes, it is a city where at virtually every corner there is a reminder of a stirring history; yes, it is a city that is capable of mounting the most spectacular arts festival in the world. Edinburgh is all of that – it is an inspiring and exciting city that draws visitors from all four corners of the globe – but there is something about Edinburgh that such fulsome praise fails to capture, and that is its gentle and lingering beauty – a beauty as evident in its secret small places as it is in its big public buildings.

I chose the word 'gentle' because that, I feel, is the special quality of the beauty that one encounters in the architecture and skylines of this city. Edinburgh is a delicate place: it is not a loud and bustling city. Its beauty is not to be found in scale and confidence (New York), in gestures of elegance (Paris), or in sheer antiquity (Rome); Edinburgh's beauty lies in the way in which it makes a gentle statement of order, reason and harmony that stays with you after you shut your eyes. Edinburgh is the Scottish Enlightenment in stone.

Of course, there is more to it than that. Edinburgh is fortunate in that much of its history has survived humanity's lamentable ability to erase the past. A walk across central Edinburgh from south to north will take you past buildings and structures that date back over four centuries. You will walk through the bloody history of sixteenth- and seventeenth-century Scotland, through the intellectual and scientific glories of the eighteenth century, and into the grandeur and excitement of the Victorian era. Here and there will be the twentieth and even the twenty-first centuries, muscling in on the already crowded streets. Edinburgh, in a sense, is a living history lesson.

How do you capture such a layered and intriguing – even sometimes rather eccentric – beauty? Poets have tried, with varying degrees of success, and novelists too. But ultimately it is to the artist we must turn, because this is a visual story. Iain and Anne Fraser decided that they would create a record of this city by commissioning four artists to sketch the city, and they would then add their words in explanation. The decision was a bold one: six sets of eyes

will see things very differently from a single set, and the result might be a city as seen by a committee. Fortunately, that has not happened, and what has resulted is a charming and engaging portrait of the city that captures exactly that quality that I mentioned earlier on: the gentle nature of Edinburgh's beauty.

The choice of medium for this sketchbook – pen and watercolour sketches – has proved to be exactly right for Edinburgh. This is a fragile city: it would not do to paint it in large slabs of colour; rather it should be approached delicately, with discreet lines and attenuated washes of colour. Because that is what Edinburgh looks like. That is how it feels.

Iain and Anne are just the guides you need for this tour. Their love for this city and their knowledge of its moods shine through the passages that accompany the sketches. Let them take you by the hand and lead you to the places that they think embody the city's character. It is a delightful journey – a journey of heart and eye that captures what it is that makes people fall in love and appreciate this town, our place, our shared and cherished home.

ALEXANDER McCALL SMITH

INTRODUCTION

A Sketchbook of Edinburgh describes a journey through the centre of one of the world's most beautiful cities, roughly encompassing the area of the World Heritage Site, and highlights our favourite aspects of the city.

This is not a history book – the story of the city has been told many times before. Instead this book is a personal tribute to a living historical, creative and cultural city which visitors will fall in love with, and vow to return to again and again, particularly with the 250th anniversary of the New Town in 2017.

Edinburgh has been described as 'pure theatre, with its battlements, crags and classical columns', but it is also a compact city, easy to explore on foot. Through a series of illustrations by four talented local artists, the book aims to capture the images and reactions that a first-time visitor might experience as they walk around Scotland's capital city.

Having lived in Edinburgh for most of our lives we wanted to include places that have meaning for us and are part of our own personal histories. We have both left the city at some stage in our lives only to be drawn back, giving us an appreciation of Edinburgh that we still feel passionately today.

After working in Asia and the USA for many years, Iain came home to Edinburgh in 1994 to escape the corporate world, and set up a business. Experience in the shipping industry and sales provided no obvious business plan. When a friend asked what his passions were, Iain replied 'coffee and elephants'. The coffee culture was just beginning, and Iain saw a new market opportunity here in Edinburgh. Hence, the Elephant House café–restaurant was born and has served good food and drink to the people of Edinburgh and visitors alike ever since. It is a stone's throw from the beautiful Greyfriars Kirk, where we were married in 2004.

It was while travelling to visit his children in New Zealand that Iain spotted, and was inspired by, Graham Byfield's beautiful *Singapore Sketchbook* in the airport bookshop. Thus the story behind our book began. We have long felt that Edinburgh lends itself perfectly to a book in a similar style. We had worked with artists Cat Outram and Keli Clark before and decided to ask them to work on this project. Catherine Stevenson became a welcome addition to the team, and in the summer of 2015 we asked the Edinburgh College of Art to set a competition for its recent graduates to find another artist to join the project. Irina Cucu joined the team, and all four artists produced the 150 outstanding illustrations for this book.

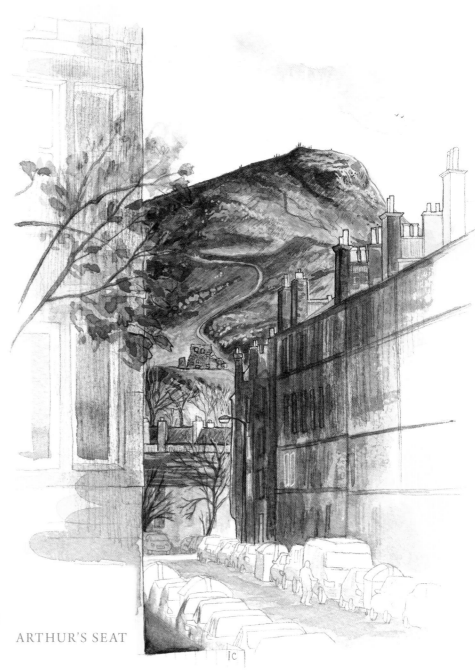

ARTHUR'S SEAT

A City of Contrasts

While researching for the book's narrative we discovered that the city's first settlers, the Gododdin tribe, built a fort where the Castle sits today, called Din Eidyn, or Dunedin, from which the name Edinburgh is derived, and which was also used by Scots settlers in southern New Zealand. Our family bond to New Zealand is heart-achingly strong, and the placenames found there reinforce that bond.

Edinburgh developed from the Castle down what is now called the Royal Mile to where the Palace of Holyroodhouse sits at the foot of the slope. The Palace is the Monarch's residence when in Edinburgh, and the open land next to it is called the Royal Park. This area is also home to Arthur's Seat, part of an extinct volcano, today the domain of runners and cyclists who enjoy an uphill challenge and a downhill sprint.

Every visitor to Edinburgh is drawn to the Castle, and within its mighty stone walls lies a fragment of history close to Anne's heart. In 1950 the Stone of Destiny was stolen from under the throne in Westminster Abbey in London by four students and driven north to Scotland where, they believed, it rightfully belonged. Anne's late uncle, Bill Craig, was one of those students. He had to face the discomfort of sitting on the stone, covered with a rug, as it was driven back to Scotland, trying to avoid the police. In 1996 the Stone of Destiny was finally lawfully returned to Scotland and can be admired for its glorious plainness in Edinburgh Castle today. Never was so much fuss made of a massive lump of rock.

While Iain's business sits on the edge of the Old Town on George IV Bridge, Anne's office is in the heart of the New Town in the Royal Society of Edinburgh on George Street. The fact that the people of Edinburgh live and work in beautiful buildings such as these reflects a city that has not given up its heritage to become a Disney-style showpiece.

The city centre, for all its beauty and age, is still a thriving business district and cultural hub.

As citizens of Edinburgh, we are proud of the city's cultural legacy, which began in the period of the Enlightenment and continues to this day, with the International Arts Festival, the Film Festival, Jazz and Blues Festival, Book Festival and the Fringe providing an annual cultural overload in the summer months.

The original International Arts Festival was in 1947, organised partly to attract visitors to the city, and partly to feed a desperate post-war need for revenue, and some much-needed fun and celebration. The Festival has flourished every August since then, transforming the city. Along with its more informal cousin, the enormous Festival Fringe, it causes the city's population to grow by half, with visitors and residents enjoying over 3,000 different shows, concerts and exhibitions. It is still by far the biggest arts jamboree in the world and a 'grow-bag' germinating and nurturing new talent. Although August is the month of fame, we like September, when the city, slightly hungover, returns to its citizens, and the light becomes ephemeral. Edinburgh was named a UNESCO World Heritage Site in 1995, and the

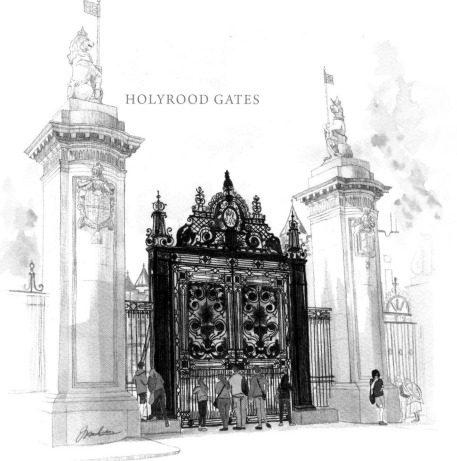

HOLYROOD GATES

world's first City of Literature in 2004. The character of Edinburgh is sometimes said to reflect a split personality as illustrated in some of its literature, such as Robert Louis Stevenson's novel *Dr Jekyll and Mr Hyde*, based on a real Edinburgh councillor. Irvine Welsh drew attention to the city's underclass in his hard-hitting novels such as *Trainspotting*, as did Ian Rankin in his Inspector Rebus murder mysteries.

Conversely, as the *Insight Guide* points out, 'the prim little city of Muriel Spark's novella *The Prime of Miss Jean Brodie*: a sniffish, cold-hearted place, full of petit bourgeois pretension and intolerance' is a little unfair. With an accent on the arts and refinement, it's true that Edinburgh is sometimes regarded as a little aloof compared with the more demonstrative, hard-edged nature of its rival city in the west, Glasgow.

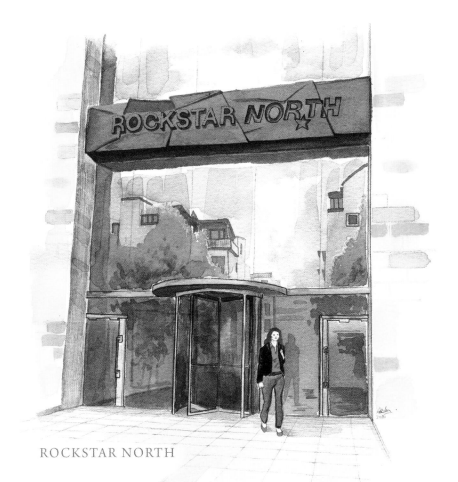

ROCKSTAR NORTH

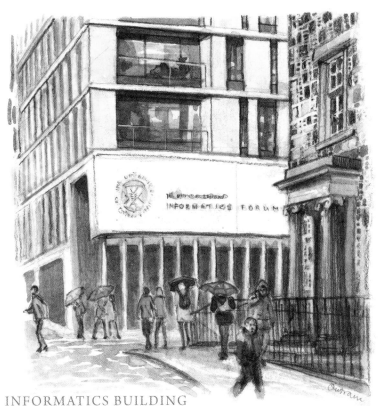

INFORMATICS BUILDING

But there is genuine warmth and a welcome in Edinburgh. The character of the city 'is a bewildering tapestry of subcultures, interests and traditions', which can both shock and seduce its visitors.

Edinburgh boasts three universities, and other teaching institutions, with more than 35,000 students. Founded in 1582, the University of Edinburgh is the youngest of Scotland's original four ancient universities, after St Andrews, Aberdeen and Glasgow. Iain's association with the University of Edinburgh is strong. His grandfather was Regius Professor of Surgery, Principal and Vice Chancellor of the institution in the mid 1940s, and his father and Anne's father both studied medicine there. Edinburgh is famous, among other disciplines, for its excellent Medical School. In the twenty-first century the University has developed a world-class School of Informatics, and Edinburgh as a city has embraced innovation. It is incubating hundreds of fledgling high-technology companies led by ambitious entrepreneurs. Anne has the privilege and excitement of working with some of them. The city is also home to one of the most successful computer games companies in the world, RockStar North.

We have always found arriving by train from the south a pleasure, especially in daylight, as the train slides into Waverley station after a scenic run up the east coast. We love our first glimpse of the extraordinary and imposing Ramsay Garden overlooking the railway. The Scottish poet Alan Ramsay owned the original 1740 house called Goose Pie, which was incorporated into this exuberant, red and white 'ice cream confection' of houses, designed by town planner Patrick Geddes in the late 1800s. The secret cat on the edge of the roof is worth a look!

The railway first arrived in the 1840s, and rival companies established their own stations, Princes Street West End, Waverley and Haymarket. The suburban train lines criss-crossed the city, making many a middle-class dressing table shake as trains rumbled by.

The closure in the 1960s of these local railways was a prime example of a lack of foresight on the part of the City Fathers. However, this cloud has a silver lining, and where the railway lines previously cut through residential areas of the city there are now well-maintained green inner-city paths and cycleways. Edinburgh today is a multi-cultural European city with a mix of nationalities

RAMSAY GARDEN

enjoying life in Scotland's capital. The large student population ensures this city is young and vibrant, at the forefront of current thinking and meeting the needs of future generations. It is a three-dimensional tapestry with a depth of colour, history, architecture and innovation.

The beauty of Edinburgh speaks for itself; we hope we have done homage to it in this book, and inspired readers to love this city as much as we do.

IAIN FRASER AND ANNE FRASER SIM

A traveller arrives off the train at Edinburgh's Waverley Station, walks up the incline on to the Waverley Bridge, and is confronted by the breathtaking panorama of the city centre.

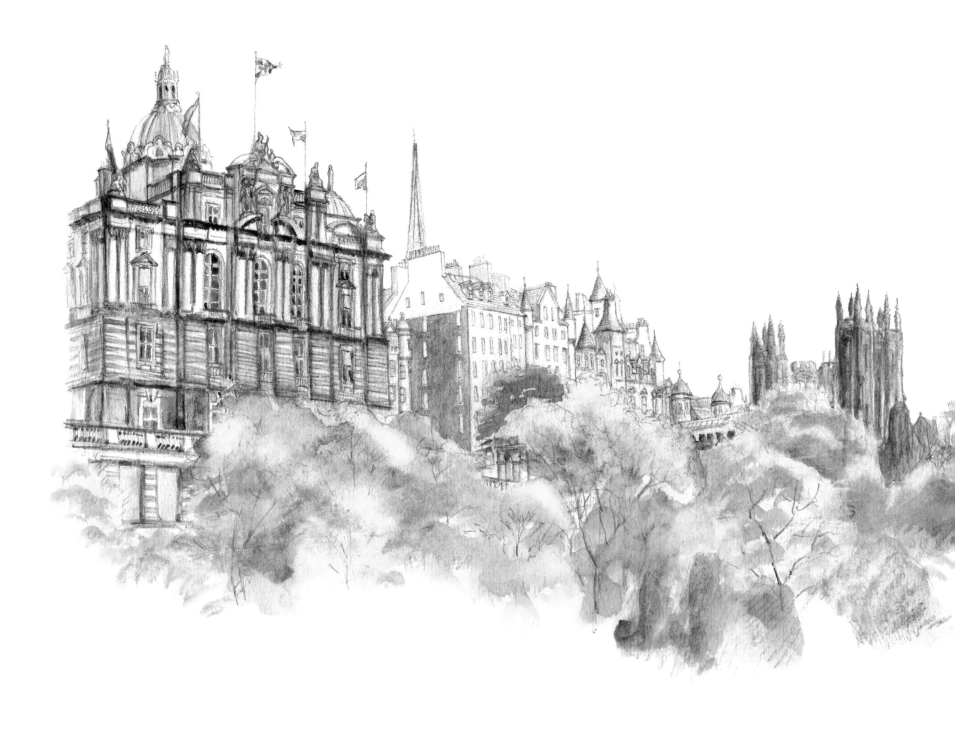

Emerging from Waverley Station on to Waverley Bridge, expect the unexpected. This is
a living historical landscape on a breathtaking scale. To the left is the majesty of the Old
Town with the Castle taking pride of place at the top of the hill. To the right spreads its
younger cousin, the New Town, with its fine Georgian symmetry.

Between the two is a valley of green calm, Princes Street Gardens, where shoppers and
office workers can escape for peace at lunchtime, and the railway line discreetly carries
travellers into the city centre, beneath the Castle Rock.

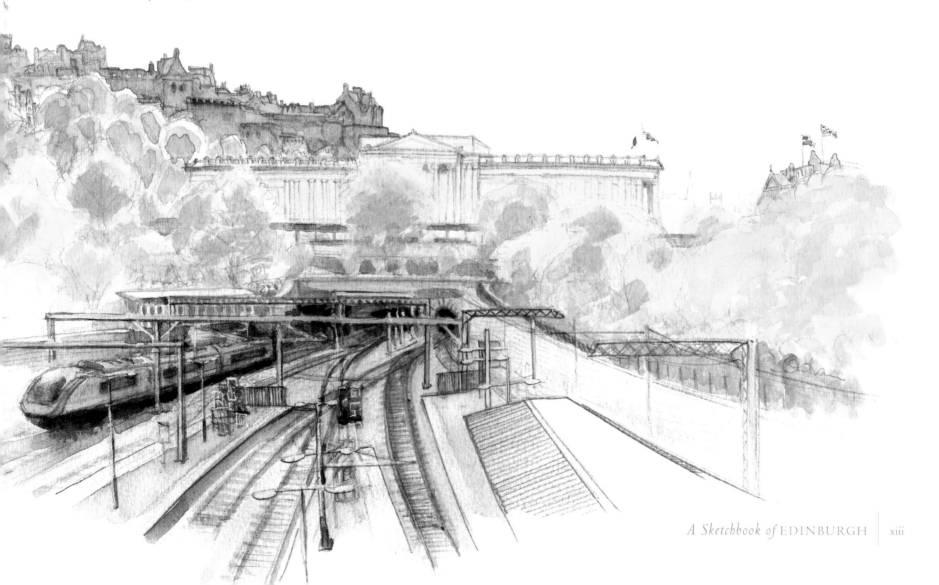

THE OLD TOWN

COCKBURN STREET

Completed in 1860 to connect the High Street to Market Street and Waverley railway station, Cockburn Street is a steeply sloping cobbled way full of quirky shops, pubs and restaurants.

The heart of Edinburgh demonstrates how the city has managed to preserve much of its medieval street plan and buildings. The Old Town grew up on either side of the spine of the Royal Mile, which consists of four consecutive streets leading down from the Castle to Holyrood Palace and its (now ruined) Abbey, namely Castlehill, the Lawnmarket, the High Street and the Canongate. Off the Royal Mile run narrow closes or vennels, often no more than a few feet wide, steeply sloping downhill on either side.

The narrowness of the Royal Mile led to the construction of some of the world's earliest high-rise buildings, up to ten storeys, from the sixteenth century onwards.

From medieval times to the mid nineteenth century the aristocracy, gentry, merchants and common folk lived cheek by jowl in these tall tenements. This affected how society functioned, with all classes rubbing shoulders together. Residents on the high levels cried 'Gardy Loo' as a warning when throwing rubbish onto the streets below, and pedestrians called back 'Haud Yer Hand' – visitors commented on 'the stench'. For many years Edinburgh was known as 'Auld Reekie' because of its polluted atmosphere of smoke from hundreds of rooftop chimneys.

In the late eighteenth and nineteenth centuries wider streets were created off the central spine of the city: the North and South Bridges, George IV Bridge at the top of the Mound, and St Mary's Street and Jeffrey Street further down. Under these bridges runs the original Cowgate, the route on which cattle were taken to market in medieval times, a place that still has a warren of underground spaces and vaults.

By the mid nineteenth century there was a sharp delineation of the classes, as the wealthy decamped to the growing New Town on the north side of the city. This left half the city's population, some 40,000 people, in what became the insalubrious slums of the Old Town, famous for their high population density and their chaotic squalor.

Today, after years of mostly sensitive restoration and rebuilding, the Old Town's labyrinthine alleyways, closes and vennels are an area to be experienced, sometimes described as 'earthy yet stylish' or 'casually cosmopolitan'.

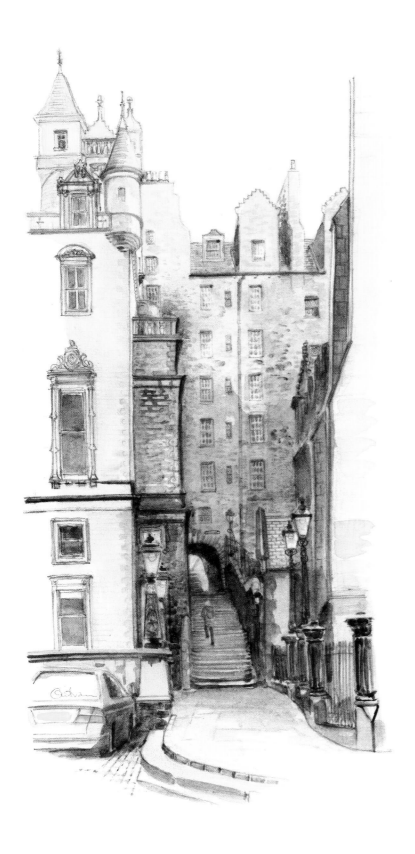

MILNE'S COURT

Milne's Court was the first open 'court', or square, of its type in Edinburgh. It was originally built at the end of the seventeenth century by Robert Mylne, Master Mason to the King. It was a fashionable place to live for many years, but is now mainly a university residence. This court is a good example of the tall tenements built side by side in the limited spaces of Edinburgh's Old Town.

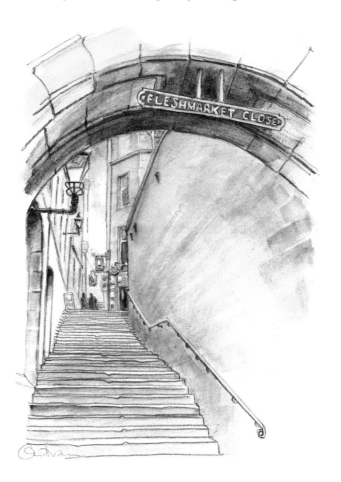

FLESHMARKET CLOSE

In the seventeenth century, Edinburgh residents had to walk up and down long flights of steps to get around the Old Town. Fleshmarket Close, running from the Royal Mile to the bottom of Cockburn Street, is a classic example. Named after a famous meat market that was located near here, this close was at one time home to Viscount Melville, famous advocate of another 'meat market': the slave trade.

Edinburgh Castle

Dominating the city from all angles and still an active military barracks as well as Scotland's foremost tourist attraction, the Castle boasts brooding dark cliff-faces on two sides, a steep grassy cliff on a third, and is only easily approachable along the Royal Mile from the east. Covering nearly nine acres in all, it is a majestic complex of buildings, the oldest of which, St Margaret's Chapel, dates from the twelfth century.

It is claimed that the Castle has been under siege 26 times throughout its history, right up to the Jacobite Rebellion of 1745. The Castle houses the Scottish Regalia, which include the Crown Jewels of Scotland and the Stone of Destiny. (The uncle of one of the authors was a member of the heroic team that pinched the stone from Westminster Abbey in 1950 to return it to Scotland.)

The Military Tattoo is held on the Castle Esplanade every August. Among other attractions is the huge Mons Meg, a fifteenth-century siege gun weighing 6 tons, built to fire 330 pound cannonballs. The barrel burst spectacularly in 1680 when it was fired to celebrate the visit of James, Duke of Albany and York (later King James VII of Scotland and II of England). It has since been restored, but is militarily inactive!

The One O'clock Gun is fired every day from the Castle ramparts. The firing of the gun, which dates back to 1861, was originally a signal for the ships in Leith Harbour to set their chronometers before setting sail, and is connected to the 'dropping ball' at the Nelson Monument on Calton Hill.

Claimed to be the oldest purpose-built visitor attraction in Scotland, the Camera Obscura was originally set up in 1835 on Calton Hill by entrepreneur Maria Theresa Short. It was moved to its current location at the top of a tenement in Castlehill, not far from the Castle, in the early 1850s. The lenses in the sixth-floor tower project a real-time image onto a concave table in the main viewing hall, to present a virtual tour of the city.

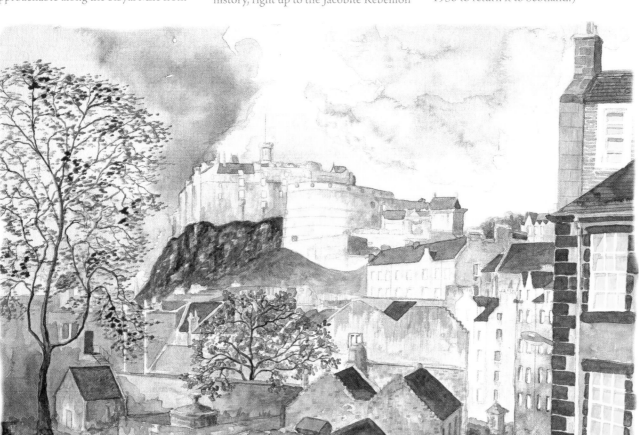

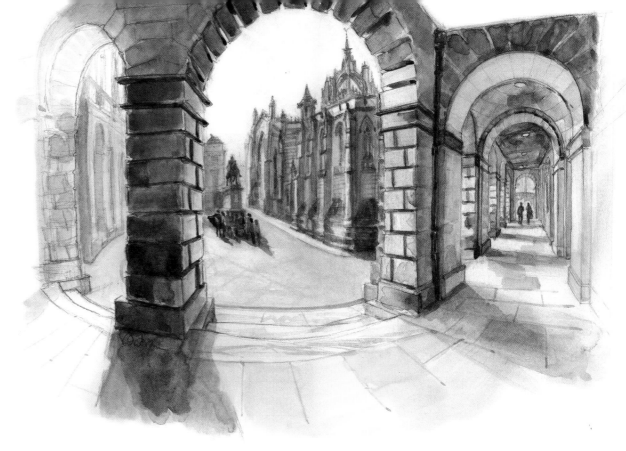

THE HEART OF MIDLOTHIAN

Built into the cobbles of Parliament Square is the Heart of Midlothian. It marks the position of the entrance to the Old Tolbooth prison and site of public execution, a place where hearts were stopped and broken.

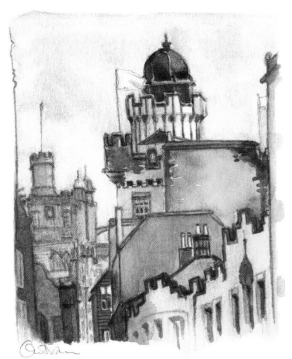

CAMERA OBSCURA

St Giles' Cathedral and Parliament Square

Also known as the High Kirk of Edinburgh, St Giles' Cathedral dates back to the twelfth century, and is named after a seventh-century French hermit. After various restorations, the form of the present church was established in the nineteenth century. The Cathedral is the Mother Church of Presbyterianism. Reformation preacher John Knox was minister of St Giles' in the 1570s and preached to both the Presbyterian congregation and the Catholic Mary Queen of Scots.

Parliament Square is the hub of the Old Town, and was described by David Wilson in 1848 as the 'busiest and most populous nook of the ancient Scottish Capital'. It was a meeting place for councillors and lawyers until the Act of Union in 1707, and thereafter for traders to do business. It is not actually a square: it surrounds St Giles' Cathedral on three sides, and sports a statue of King Charles II in front of the Supreme Court. Outside the Cathedral is the Mercat Cross, where Royal proclamations were read. The 1885 cross, which still stands, has part of the original fourteenth-century cross built into it.

The Canongate

MUSEUM OF CHILDHOOD

This was the first museum in the world dedicated to the history of toys, games and all aspects of childhood. It is housed in two historic buildings at South Gray's Close on the Royal Mile. There are costumes for dressing up, a Victorian street and a 1930s classroom. Originally privately owned, it was taken over by Edinburgh Council in the 1980s.

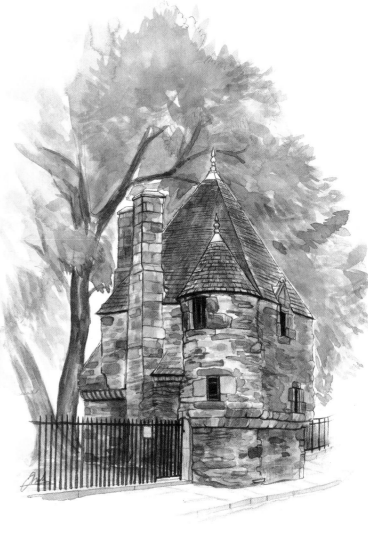

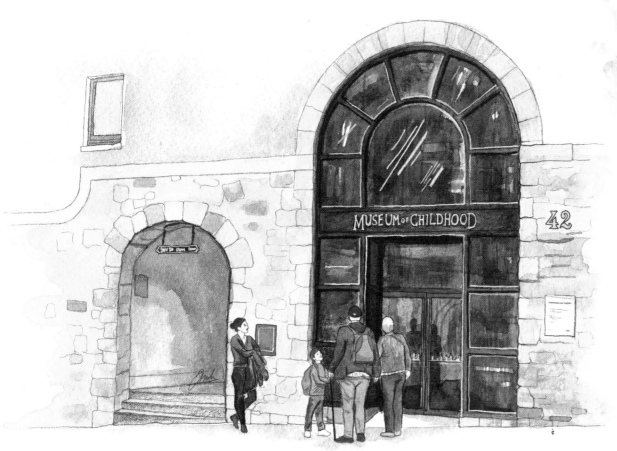

QUEEN MARY'S BATH HOUSE

The name of Queen Mary's Bath House is unlikely to be strictly accurate; this odd little sixteenth-century building on the edge of Holyrood Palace is thought to have been a garden pavilion when it was part of the old wall surrounding the Palace. Nearby 'Croft-an-Righ' was the King's 'croft', where much of the produce for the Palace was prepared and delivered in the sixteenth and seventeenth centuries. It is an intriguing old building, now restored and used for sheltered housing.

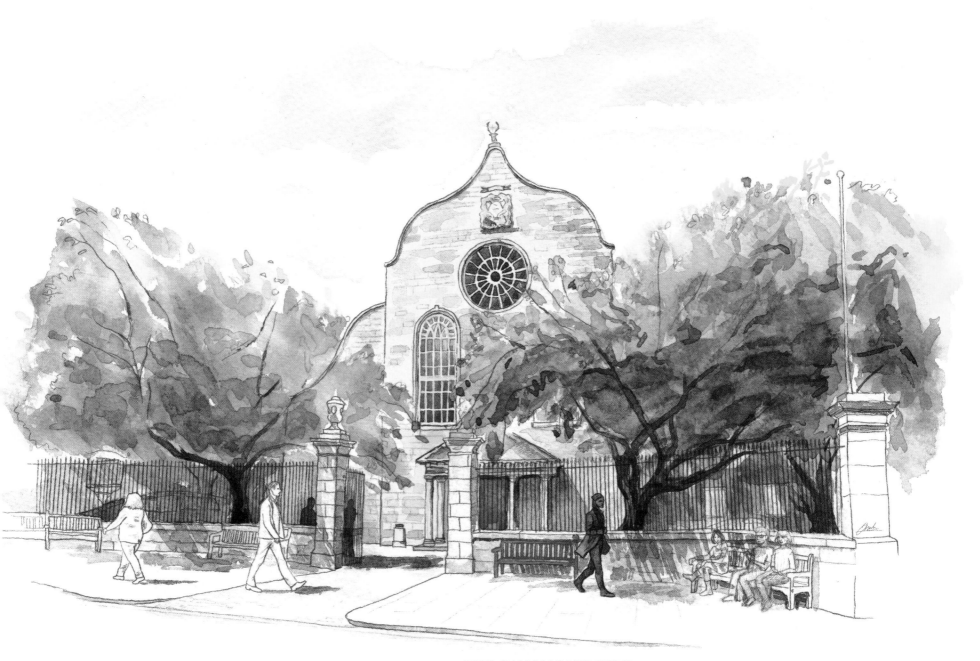

THE CANONGATE KIRK

The Canongate Kirk is the Parish Church of the Royal Family when they are resident in Holyrood Palace, and of Edinburgh Castle. It is a congregation of the Church of Scotland and opened for worship in 1691. Outside the church gates there is an eye-catching statue of the poet Robert Fergusson walking. The economist Adam Smith and Robert Burns' 'Clarinda' (Agnes Maclehose) are among those buried in the graveyard.

Greyfriars

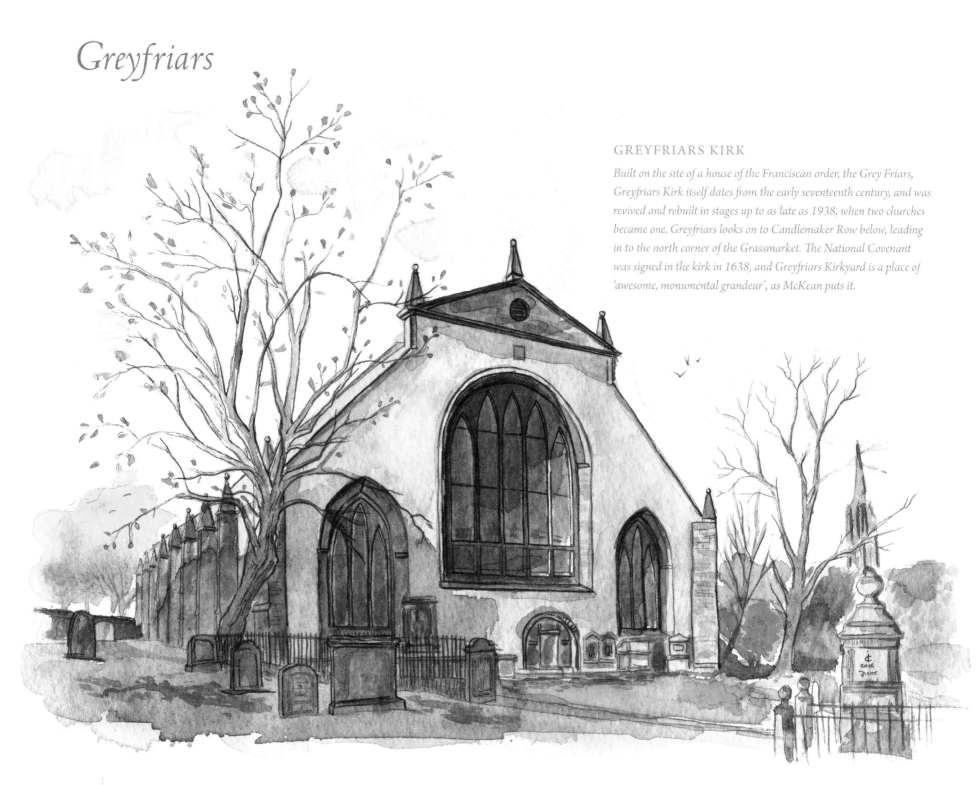

GREYFRIARS KIRK

Built on the site of a house of the Franciscan order, the Grey Friars, Greyfriars Kirk itself dates from the early seventeenth century, and was revived and rebuilt in stages up to as late as 1938, when two churches became one. Greyfriars looks on to Candlemaker Row below, leading in to the north corner of the Grassmarket. The National Covenant was signed in the kirk in 1638, and Greyfriars Kirkyard is a place of 'awesome, monumental grandeur', as McKean puts it.

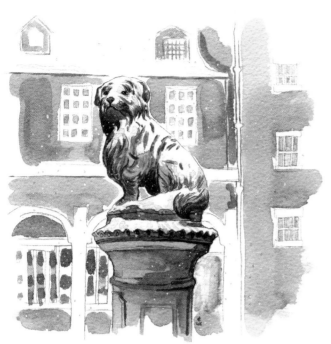

GREYFRIARS BOBBY

Greyfriars Bobby was a Skye Terrier who (the tale goes) loyally kept vigil on his master's grave in Greyfriars Kirkyard for fourteen years until his own death in 1872. Bobby's statue stands opposite the entrance to the Kirkyard.

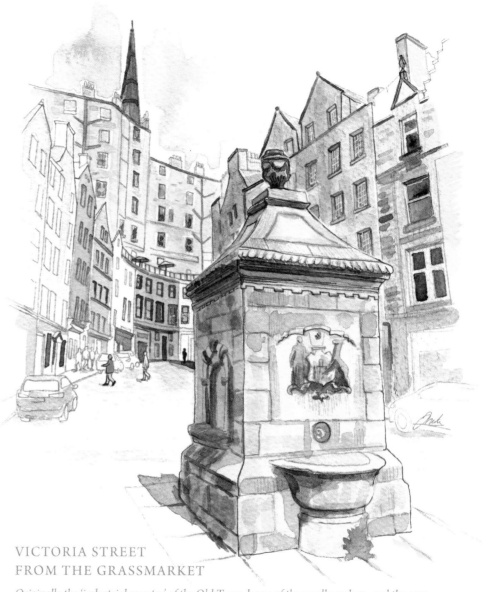

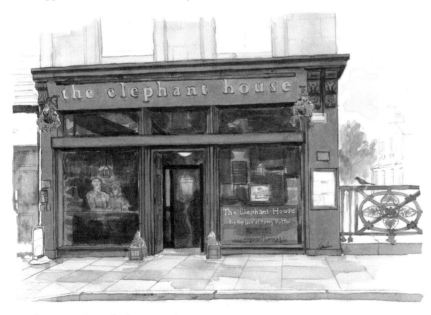

A rather nice café not far from Greyfriars

VICTORIA STREET
FROM THE GRASSMARKET

Originally the 'industrial quarter' of the Old Town, home of the candle makers, and the corn, meat and horse markets, the Grassmarket was built in the deep valley on the south side of Edinburgh Castle well below the surrounding higher-level thoroughfares. McKean describes a 'smelly, busy, bustling, place of workers surrounded by inns . . . it provided a bolt-hole for the dispossessed . . . and the disaffected'. It was also for years the place for public executions, and the site of the notorious Porteous Riots of 1736.

The Grassmarket remains one of Edinburgh's most dramatic urban spaces, a mostly pedestrianised rectangular cobbled area, 230 metres long, under the lee of the Castle cliff. It is one of the magnets of the city's tourist industry, particularly during the Edinburgh Festival, and is at the heart of Edinburgh's dramatic history. At the north-east corner, Victoria Street curves uphill from the West Bow and is full of small shops and restaurants.

THE NEW TOWN

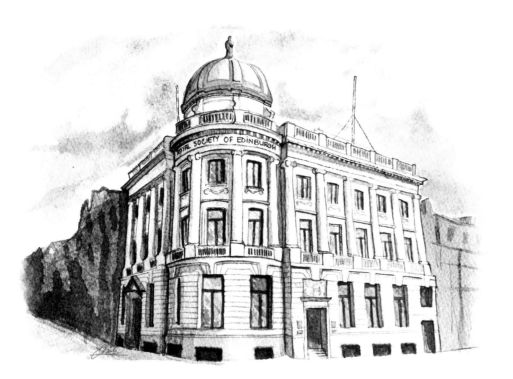

THE ROYAL SOCIETY OF EDINBURGH

The Royal Society of Edinburgh, Scotland's National Academy, is housed in an imposing building at the junction of George Street and Hanover Street in the heart of the New Town. The Society provides independent advice to government, supports researchers and entrepreneurs, and hosts lectures and conferences across all disciplines. Founded in 1783 by Royal Charter, it has 1,600 Fellows from academia, business, the arts and industry. Sir Walter Scott was the third President, and famous Fellows include Adam Smith, James Clerk Maxwell, Alexander McCall Smith, J. K. Rowling, and Professor Peter Higgs.

The New Town of Edinburgh, named a World Heritage Site in 1995, has been described as Europe's finest example of classical town planning. This outstanding area of planned Georgian urban development, the brainchild of the visionary Lord Provost George Drummond, displays an elegance of form which has managed to survive subsequent Victorian and Edwardian neglect as well as unsympathetic twentieth-century planning and development policies.

In Charles McKean's *Edinburgh: An Illustrated Architectural Guide* Gordon Davies describes 'the rowdy confusion and intimate intricacy of the Old Town, set on its hill culminating in the Castle, and overlooking the formal stately grandeur of James Craig's New Town... The Old and New complement each other, and there is interest and diversity in each, but in both cases a unity which provides a harmony lacking in many other cities.'

The idea of Edinburgh's New Town was originally proposed as early as 1688. Various delays culminated in an architectural competition being held in 1766 for a suitable plan for the layout, which was won by young architect James Craig. Building work started in the early 1770s on a variation of his original plan, which consisted of a simple grid-iron plan of three parallel main streets with a square at each end. The names of the streets and the squares were chosen to celebrate the Union and the Hanoverian monarchy.

The middle street, George Street, was named after George III. On the north side of this was Queen Street, and on the south Princes Street, facing the Old Town and the Castle. Princes Street had originally been proposed as St Giles' Street, but this was opposed by King George because of the name's association with a slum area on the edge of the City of London. The grand squares were named St Andrew Square at the east end and, originally, St George's Square at the west end. However, the latter was changed to Charlotte Square, named after Queen Charlotte, to avoid confusion with George Square in the university area south of the Old Town.

The New Town was designed to provide spacious living in wide, symmetrical streets of terraced townhouses, with open squares and gardens, in complete contrast to the Old Town. Many wealthy Scots set up home there. Most of the golden sandstone for the neo-classical architecture of New Town Edinburgh came from nearby Craigleith Quarry, which was active from 1615 to 1942.

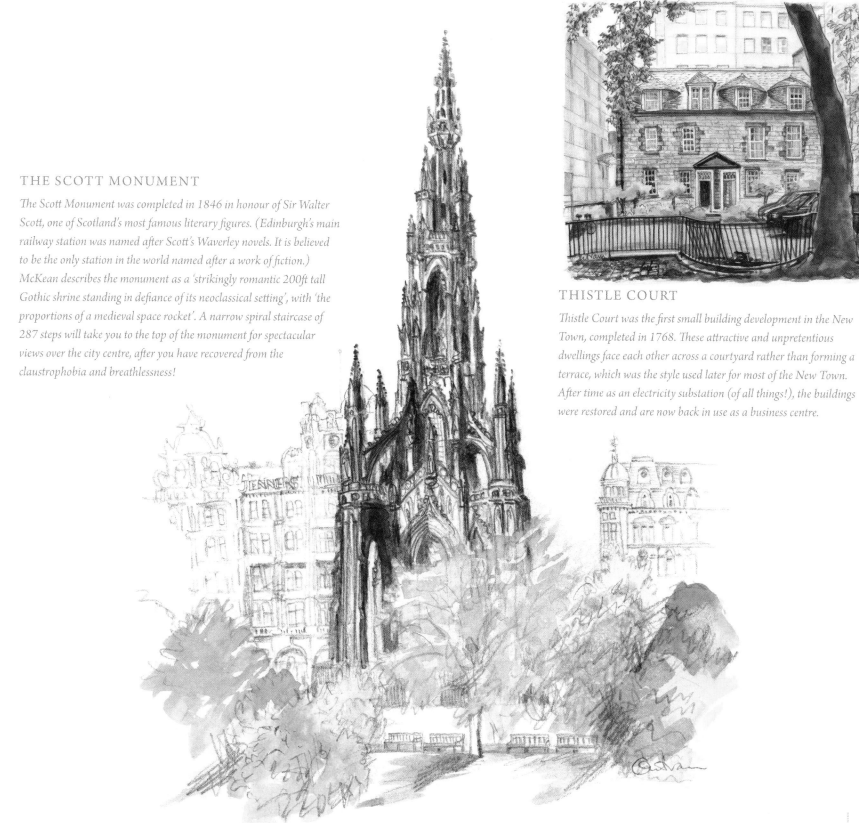

THE SCOTT MONUMENT

The Scott Monument was completed in 1846 in honour of Sir Walter Scott, one of Scotland's most famous literary figures. (Edinburgh's main railway station was named after Scott's Waverley novels. It is believed to be the only station in the world named after a work of fiction.) McKean describes the monument as a 'strikingly romantic 200ft tall Gothic shrine standing in defiance of its neoclassical setting', with 'the proportions of a medieval space rocket'. A narrow spiral staircase of 287 steps will take you to the top of the monument for spectacular views over the city centre, after you have recovered from the claustrophobia and breathlessness!

THISTLE COURT

Thistle Court was the first small building development in the New Town, completed in 1768. These attractive and unpretentious dwellings face each other across a courtyard rather than forming a terrace, which was the style used later for most of the New Town. After time as an electricity substation (of all things!), the buildings were restored and are now back in use as a business centre.

Princes Street and the Mound

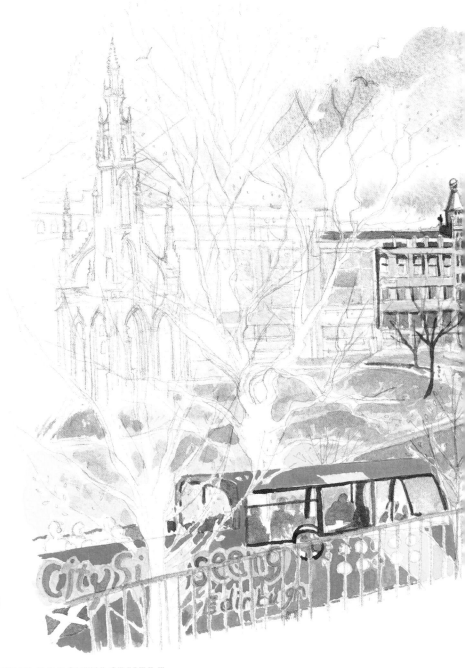

Princes Street was once described by Robert Louis Stevenson as a 'terrace of palaces', but over the nineteenth and twentieth centuries it was redeveloped and became dominated by shops and traders. McKean describes it as an 'architectural fruit salad', and 'a reproach to the order of the New Town'. Certainly commerce arrived early to Princes Street, which was originally planned as a one-sided development facing the Castle and the Old Town, and never earned the architectural cachet of George Street. There were various plans to redesign and rebuild Princes Street in 1938, 1949 and 1954, the final plan incorporating modernist buildings with high-level walkways, but (thankfully) these were never carried out.

The Old and New Towns were originally separated by the polluted 'Nor' Loch', which was eventually drained between 1770 and 1830 to create Princes Street Gardens. The railway was built in 1846 to connect Haymarket and Waverley Stations, in a cutting surrounded by the 30 acre gardens. Concerts and other events are held in the gardens throughout the year, including Edinburgh's famous Hogmanay celebrations.

The Royal Scottish Academy (RSA) was founded in 1826 to promote contemporary Scottish art and architecture, and is independently funded, a unique position in Scotland. The building was extended in 1860 to a William Playfair design. More recently an underground walkway, including a restaurant, has been added to link the RSA to the neo-classical National Gallery of Scotland, also designed by Playfair, which opened to the public in 1859. It houses an extensive collection of national and international art from the early Renaissance to the start of the twentieth century. The snake-like route of the Mound runs up past the two galleries from Princes Street to the Royal Mile, and is the major connection between the Old Town and New Town.

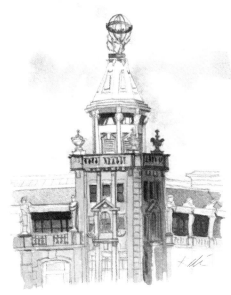

THE FORSYTH SPHERE

In 2012 the Forsyth 'armillary sphere' was removed from the top of the corner tower of what had been a much loved department store, R. W. Forsyth, which closed in the 1980s and is now inhabited by shops and a hotel. The six-storey baroque-influenced building, the first steel-framed structure in Scotland, was designed by J. J. Burnet and completed in 1907. After a public outcry at its removal, the 3-tonne sphere was renovated and restored to its rightful position in 2016 as a memorable part of Edinburgh's skyline.

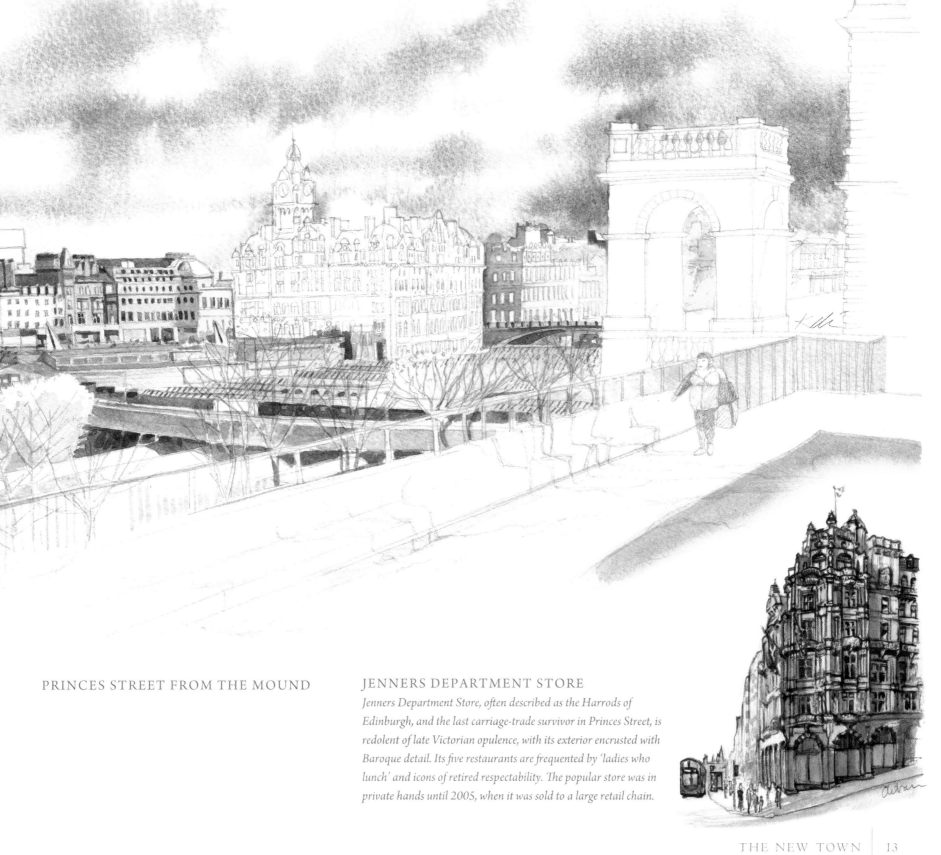

PRINCES STREET FROM THE MOUND

JENNERS DEPARTMENT STORE

Jenners Department Store, often described as the Harrods of Edinburgh, and the last carriage-trade survivor in Princes Street, is redolent of late Victorian opulence, with its exterior encrusted with Baroque detail. Its five restaurants are frequented by 'ladies who lunch' and icons of retired respectability. The popular store was in private hands until 2005, when it was sold to a large retail chain.

George Street, Queen Street and Heriot Row

George Street is officially the main street of the New Town. Only in the last twenty years has a plethora of high street shops opened there. Previously the buildings housed mainly banks, insurance companies and offices for professional firms. Dotted among these were the (now much lamented) Edinburgh Bookshop, Melrose tea merchants, and a famous ironmonger and general household goods store called Grays, which only closed in 2010. The architecture is well worth a look on a slow walk – particularly St Andrew's and St George's West Church, the recently refurbished Assembly Rooms, and the Royal Society of Edinburgh. Other Georgian and Victorian facades still exist, but now house restaurants and shops.

Queen Street is the northern equivalent of Princes Street in James Craig's New Town plan, and looks on to the private Queen Street Gardens. McKean describes 'plain, north-facing houses of startling similarity' which were 'the roost of lawyers, bankers, painters and minor gentry', which is perhaps slightly unfair. There is some lovely architecture along the terrace, including the Royal College of Physicians, the National Portrait Gallery and other restored early townhouses.

Heriot Row, dating from the early 1800s, borders the beginning of the 'northern New Town', an expansion resulting from the success of the New Town. This wide terrace faces Queen Street across the gardens and is still largely residential.

It is famous for being one of the most expensive streets in the UK outside London, and its houses look much the same today as when they were built, with their classic palace fronts, ashlar facades, astragals and fanlights, decorative ironwork and ornate lamp posts. Robert Louis Stevenson wrote about 'Leerie the Lamplighter' when he lived here, and other residents included the nineteenth-century Liberal politician Robert Munro and the writer and documenter of New Town life Elizabeth Grant.

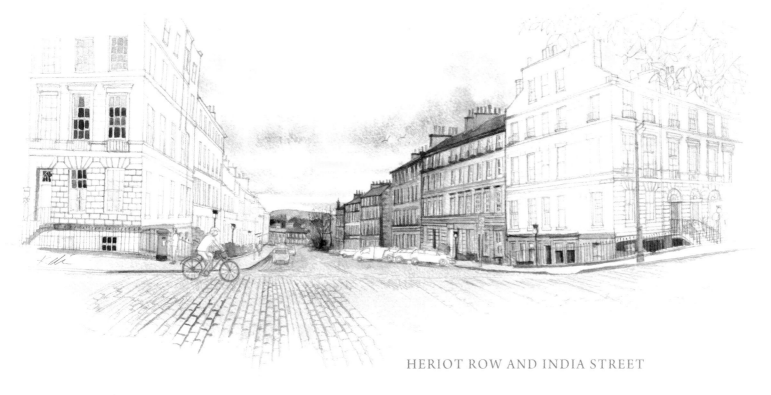

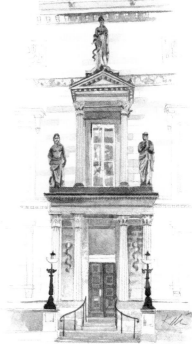

HERIOT ROW AND INDIA STREET

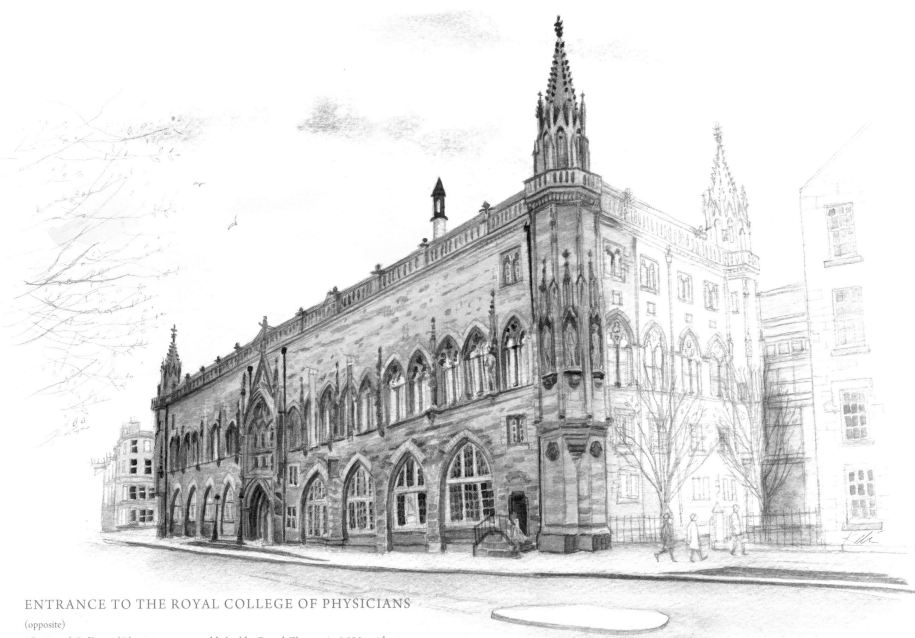

ENTRANCE TO THE ROYAL COLLEGE OF PHYSICIANS

(opposite)

The Royal College of Physicians was established by Royal Charter in 1681, with over half of its Fellows practising medicine outside Scotland. The College published the first Pharmacopoeia, and founded the first (free) public dispensary in the late seventeenth century. The current buildings in 8–12 Queen Street were acquired in stages between 1846 and the mid twentieth century, and are a superb example of Edinburgh architecture. It is said that, in the days when the buildings were private houses, there was a tunnel into Queen Street gardens opposite, where residents took their washing to hang out to dry!

THE SCOTTISH NATIONAL PORTRAIT GALLERY

The Scottish National Portrait Gallery is a beautiful building in which to spend a happy few hours; McKean refers to it as a 'fantastic extruded French Gothic medieval palace in red sandstone', with 'corner towers dripping with sculpted figures from Scots history'.

THE WEST END

To the west of Princes Street and George Street there is a blend of architectural styles from Georgian to twenty-first century. The West End was the last part of the 'first' New Town to be built according to the original neo-classical ideal. After the sins of redevelopment of the 1960s, New Town architecture and heritage were protected by the New Town Conservation Committee, formed in 1970, which evolved to become the Edinburgh World Heritage Trust in 1999.

The northern half of the West End includes crescents of fine Georgian terraced houses, and many other beautiful buildings. The buildings on the north side of Charlotte Square, designed by Robert Adam, include Bute House, the official residence of the First Minister of Scotland, and the National Trust's Georgian House, restored in the 1970s. West Register House is at the centre of the west end of Charlotte Square. It was originally a church, designed by architect Robert Reid in 1811. Behind this building are pathways to the cobbled streets of Queensferry Street and Randolph Place, with their little bars and restaurants, which bring a down to earth character to this part of the city. Beyond are the more stately Melville Street and

St Mary's Cathedral.

During August the Edinburgh International Book Festival sets up camp in a tented village in Charlotte Square Gardens, bringing writers from all over the world to inspire and entertain readers, watched over by an imposing statue of Prince Albert on horseback. Edinburgh's West End is on a much smaller scale than London's, but is similar in its range of cultural venues, mainly housed in and around Lothian Road.

RUTLAND SQUARE

Rutland Square, developed in the 1830s, is a calm green space a short walk from the bustle of the West End. Its name remains intriguingly obscure. The Square houses offices, residences and the Scottish Arts Club, with private gardens in the centre. Number 15 Rutland Square was once owned by distinguished architect Robert Rowand Anderson, who designed the Scottish National Portrait Gallery.

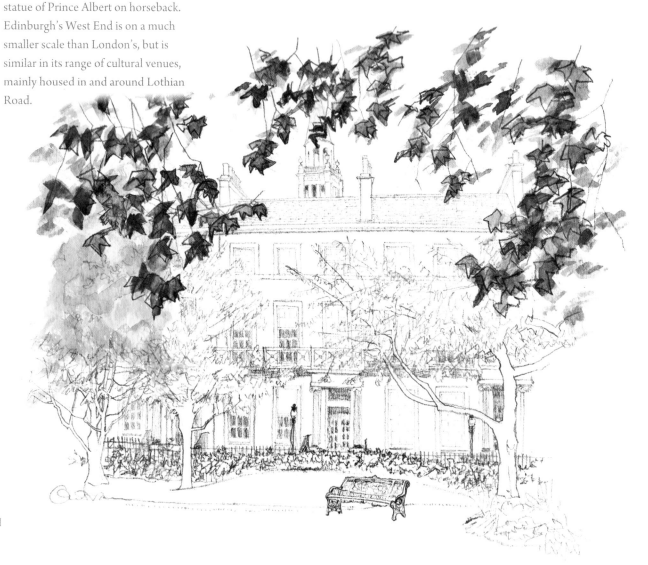

DRUMSHEUGH GARDENS

This is a triangular garden area close to Melville Street in the West End, overlooked on all three sides by rows of handsome Victorian terraced houses. The name 'Drumsheugh' means 'high ridge and ditch' in old Scots, and the gardens are on the site of the old Drumsheugh House.

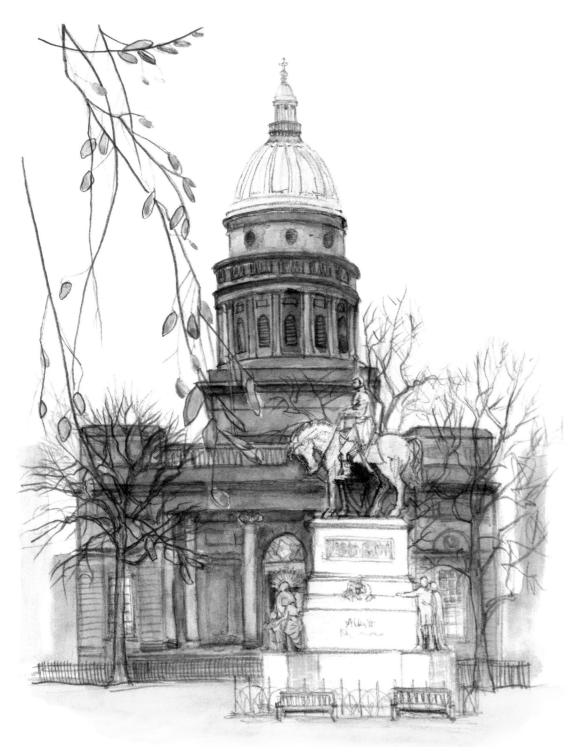

WEST REGISTER HOUSE FROM CHARLOTTE SQUARE

Princes Street West

The grand red sandstone Waldorf Astoria Hotel is a former station hotel (originally the Caledonian Hotel, and still often nicknamed 'the Caley'), welcoming visitors from all over the world. McKean calls it a 'wonderfully blowsy red sandstone intrusion into classical Edinburgh' and 'unusually vigorous for Edinburgh: rumoured to have been designed and built in Glasgow, squeezed upon a train, to erupt at the other end of the tunnel'. Built in 1903 as part of the Princes Street railway station (which closed in 1965), the hotel was designed as a rival to the North British Hotel at the east end of Princes Street.

The hotel faces a House of Fraser department store, which aims to lure visitors from their luxurious quarters to shop until they drop. The shop was previously Binns department store, and this area is still known locally as Binns Corner, with its famous clock, a popular landmark for people to meet their friends.

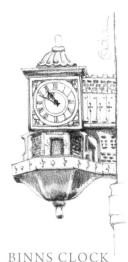

BINNS CLOCK

Binns clock on the corner of the House of Fraser department store is a favourite West End meeting place.

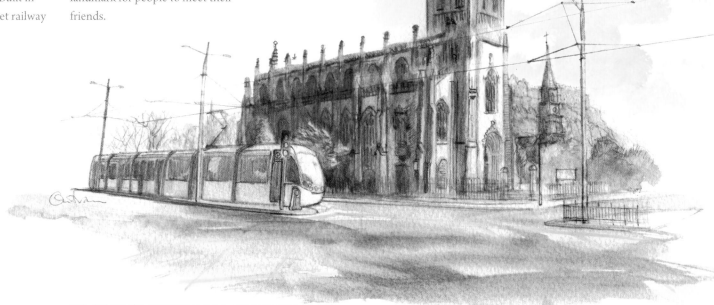

ST JOHN'S EPISCOPAL CHURCH

St John's Episcopal Church, on the corner of Lothian Road, dominates the west end of Princes Street. It dates from the early nineteenth century and overlooks one of the busiest junctions in the city. The church has a magnificent collection of stained glass windows, including some by the Edinburgh studio Ballantyne and Allan. Its Presbyterian neighbour, St Cuthbert's, boasts a beautiful stained glass window by Tiffany of New York.

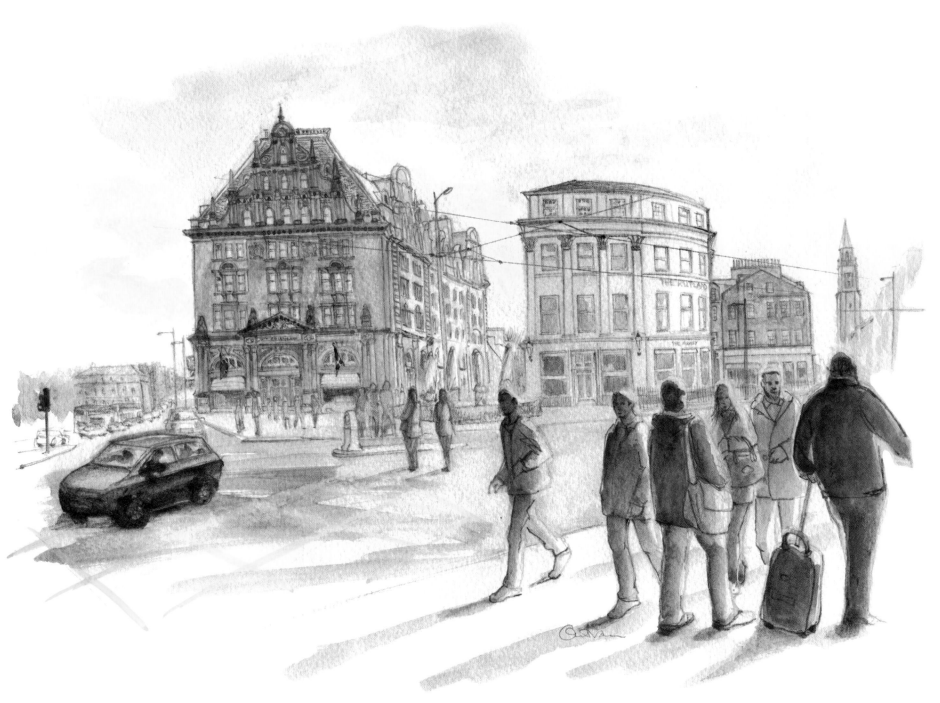

THE WALDORF ASTORIA HOTEL AT THE HEART OF THE WEST END

Lothian Road

Lothian Road is a busy thoroughfare running south from the west end of Princes Street, in the shadow of Edinburgh Castle to the east. It is home to a range of arts venues clustered around the Usher Hall.

The Usher Hall, with its unusual curved walls and domed roof, was built in the Beaux-Arts style and opened in 1914. Andrew Usher, scion of a famous distilling family, donated £100,000 to the City of Edinburgh in 1896 to fund the building of the concert hall. The Usher Hall is famous for its superb acoustics and magnificent organ. It seats

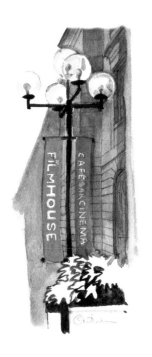

more than 2,000 people and hosts a wide range of concerts and other events. Major renovation and refurbishment work was completed in 2009 at a cost of £25 million.

The Royal Lyceum Theatre, next to the Usher Hall, was built in 1883 on behalf of two local theatre managers. The building was bought by Edinburgh Corporation in 1965 and leased to the Theatre Company as permanent residents. The Lyceum celebrated its 50th anniversary in 2015, and is one of Scotland's leading theatres, seating 650. It is a major venue for the Edinburgh International Festival.

The Traverse Theatre, also close to the Usher Hall, is a lively Fringe venue during the Festival. It was founded in 1963 and is associated with innovative new writing and emerging talents. The theatre is renowned for commissioning radical, cutting-edge writing and has launched the careers of many playwrights.

The Filmhouse cinema, across the road from the Usher Hall, opened in 1978 in a former church, and is home to the Edinburgh International Film Festival. It is a world-class independent cinema, with three screens showing a wide range of international films.

THE WATCHTOWER
This little circular building on the corner of King's Stables Road (which runs from Lothian Road to the Grassmarket) was a watchtower built in 1827 to guard against grave robbers. It was restored in 1990 and is now in use as an office.

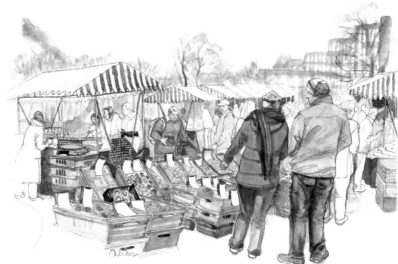

CASTLE TERRACE FARMERS' MARKET
Just off Lothian Road lies Castle Terrace, where the Farmers' Market is held every Saturday. With the spectacular backdrop of Edinburgh Castle, the Market boasts a huge variety of fresh local produce that is popular with locals and tourists alike.

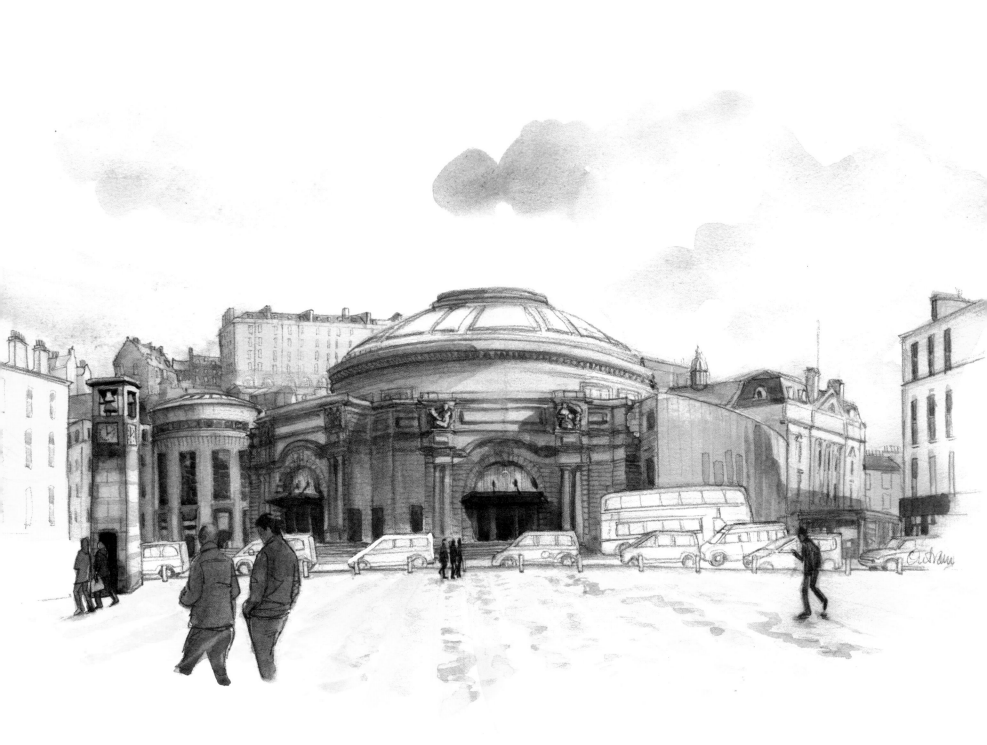

THE USHER HALL AND LYCEUM THEATRE

Melville Street

Just to the west of the city centre, off Queensferry Street, is Melville Street, a wide and elegant terrace of silver-grey sandstone Georgian buildings oozing refinement. The street's namesake, Henry Dundas, 1st Viscount Melville, was an unsavoury but powerful character who opposed the abolition of slavery. He was Solicitor General for Scotland in 1766, before becoming Lord Advocate and then Lord of the Admiralty. Suspicions arose about financial management of the Admiralty, and he was impeached for the misappropriation of public money. Although he was acquitted, his career in public office was over. He divorced his wife in 1778 and, as was the law at the time, he retained her wealth, their home and their children. Lord Melville died aged 69 but his first wife lived to the grand old age of 97.

It is perhaps fitting that St Mary's Episcopal Cathedral at the west end of Melville Street sits with its back on the street. The main Cathedral building was completed in 1879 after two sisters, Barbara and Mary Walker, came up with the idea of endowing their property to the Diocese of Edinburgh for the building of a Cathedral. The building was designed by Sir George Gilbert Scott and was inspired by early Gothic churches. In honour of the sisters, two western spires were added during the First World War and are affectionately known as the Barbara and the Mary.

Melville Street is now a hotbed of international relations, boasting the Danish, Dutch, Italian, Russian and Japanese consulates. At one time a private boys' school, Melville College, was housed at the east end of the street.

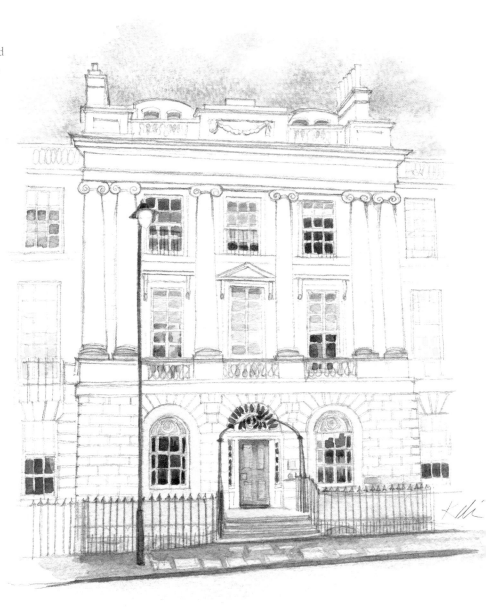

THE HOUSE ON MELVILLE STREET WHERE LORD MELVILLE ONCE LIVED

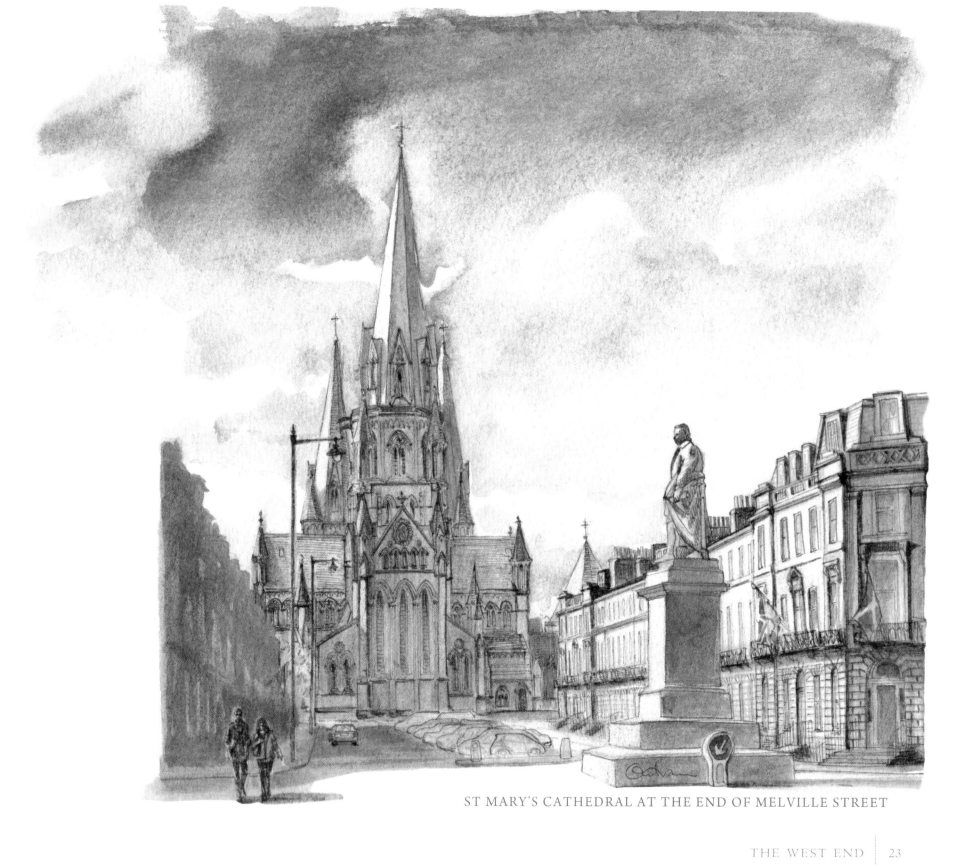

ST MARY'S CATHEDRAL AT THE END OF MELVILLE STREET

THE EAST END

The East End includes the eastern edges of the New Town, Regent Road and the area around Calton Hill. St Andrew Square, at the east end of George Street, is still recognised as the banking centre of Scotland, with some memorable financial monuments, despite the banking dramas of the 2000s. The recently restored Royal Bank of Scotland building at number 36 was built in 1771 as an elegant Palladian villa for Sir Lawrence Dundas. The Square itself is full of grand buildings from all eras, including glass-fronted edifices of the twenty-first century, with two famous Victorian pubs tucked away in the south-east corner: the Café Royal and the Guildford Arms.

At the east end of Queen Street, St Mary's (Catholic) Cathedral looks down Leith Walk, the main thoroughfare linking Edinburgh to the port of Leith. It is the seat of the Catholic Archbishop of St Andrews and Edinburgh, and dates from 1814.

Calton Hill at the top of Leith Walk has fine views over Princes Street and the Castle. It is a favourite area for viewing the fireworks displays at the end of the Edinburgh Festival, and at New Year, and is home to some surprising and dramatic monuments.

Regent, Carlton and Royal Terraces, built in the early nineteenth century, form an impressive parade of grand townhouses overlooking the Old Town and Royal Park. It is said that these terraces were originally bought by wealthy Leith merchants, so that they could look straight down the mile of road, 'Leith Walk', to the port of Leith and watch their ships arrive and depart.

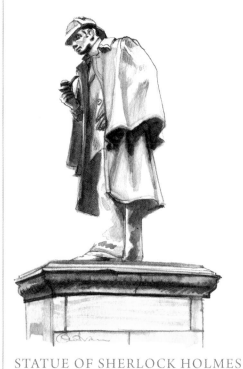

STATUE OF SHERLOCK HOLMES

This statue, on Picardy Place at the top of Leith Walk marks the birthplace of Sir Arthur Conan Doyle.

THE CAFÉ ROYAL - *where the authors met.*

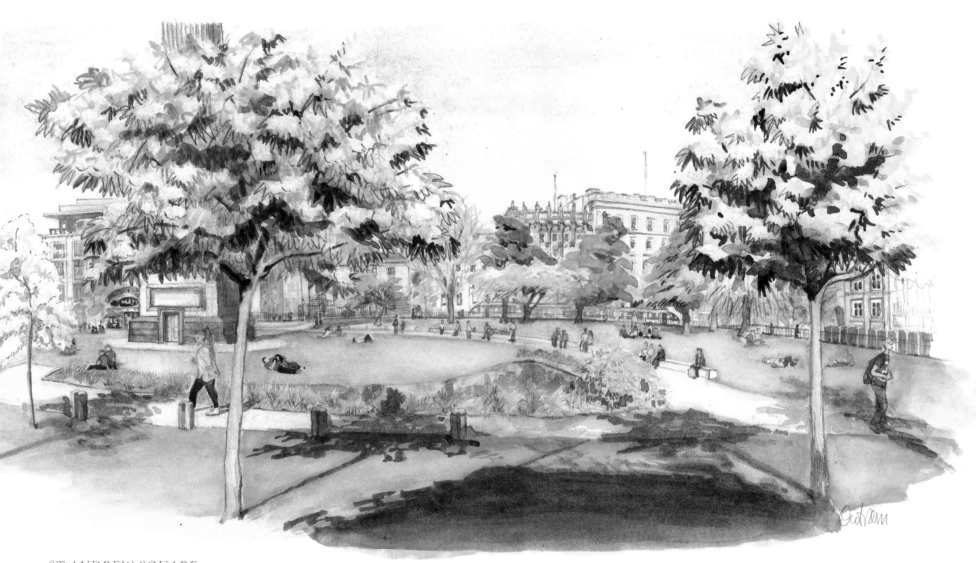

ST ANDREW SQUARE

Princes Street East

The Balmoral Hotel, with its huge clock tower, dominates the east end of Princes Street. Originally the North British Station Hotel, it was built between 1895 and 1902 to serve travellers arriving at Waverley Station below. There was originally an elevator leading directly into the railway station, and the clock on the hotel tower has always been set three minutes fast to ensure travellers catch their trains. Traditionally its rival was the Caledonian Hotel at the west end of Princes Street, which was also once a station hotel. The architect for the North British Hotel, William Hamilton Beattie, also designed Jenners department store. The Victorian architecture, with its ornate decoration, four square domed towers and oriel windows, is described by McKean as a 'landmark lacking landmark quality'.

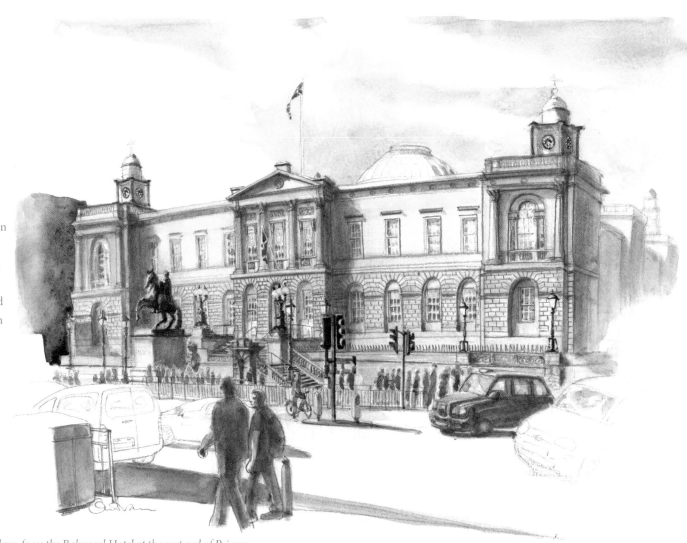

REGISTER HOUSE

Register House, by the architect Robert Adam, faces the Balmoral Hotel at the east end of Princes Street. It was completed in 1774 as Edinburgh's new Public Records Office and is home to the National Archives of Scotland. It has been called 'the most resplendent classical building in Edinburgh'. A statue of the Duke of Wellington on horseback sits proudly in front.

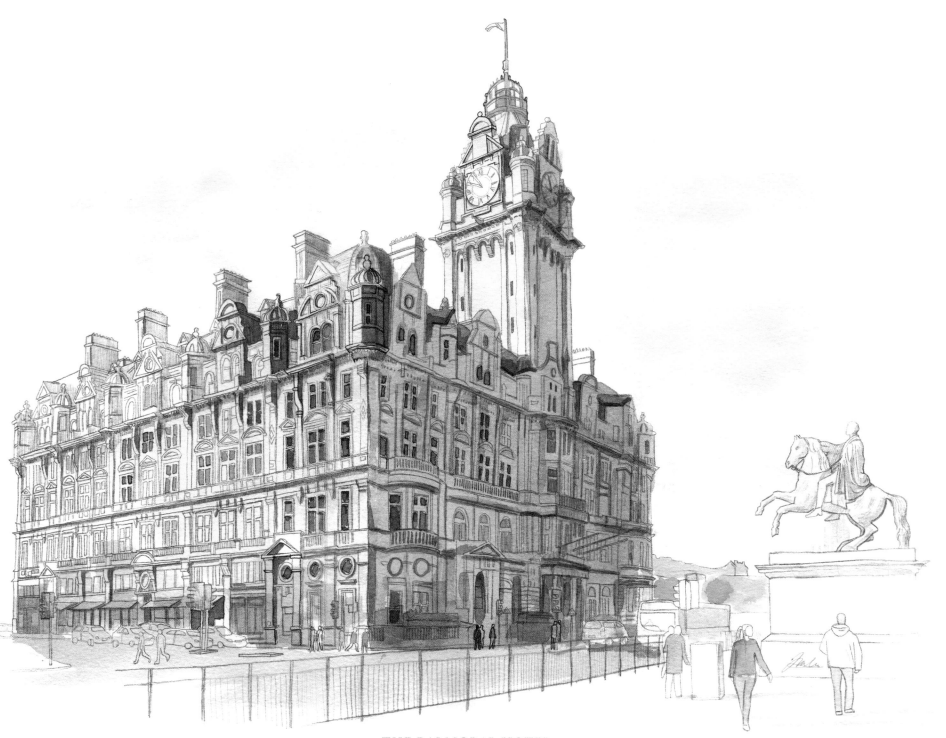

THE BALMORAL HOTEL

Calton Hill

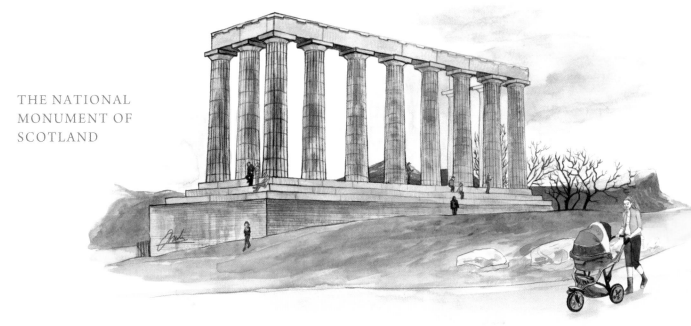

Calton Hill, accessed from Regent Road on the south or Royal Terrace on the north, provides panoramic views over the city. It contains a hotch-potch of buildings, beautiful and strange. The planned National Monument to celebrate those who died in the Napoleonic Wars was abandoned in 1822 when money ran out, so only twelve pillars of an intended 'Parthenon' designed by celebrated architect William Playfair are actually in place. It is sometimes referred to as 'Edinburgh's shame' but is a popular landmark. The City Observatory, built in 1818, and the Nelson Monument with its timeball mechanism, are also on Calton Hill.

THE NATIONAL
MONUMENT OF
SCOTLAND

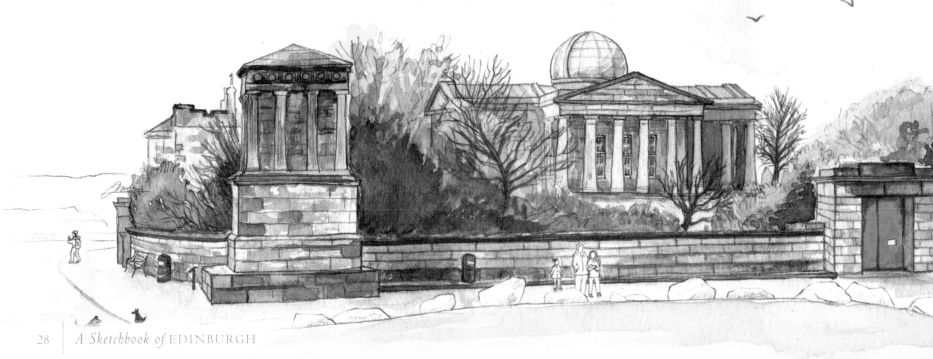

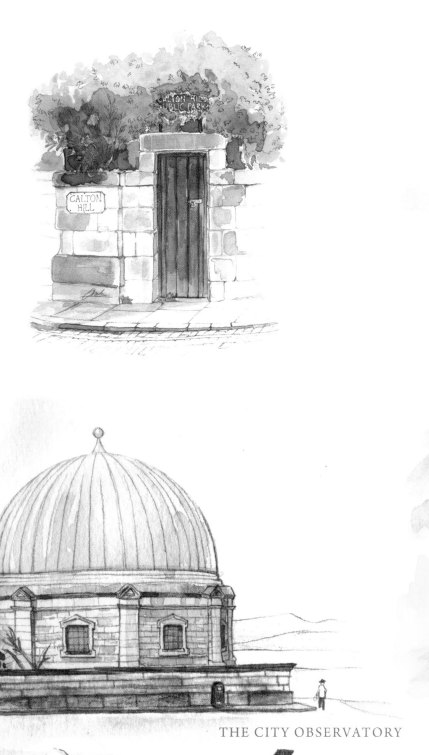

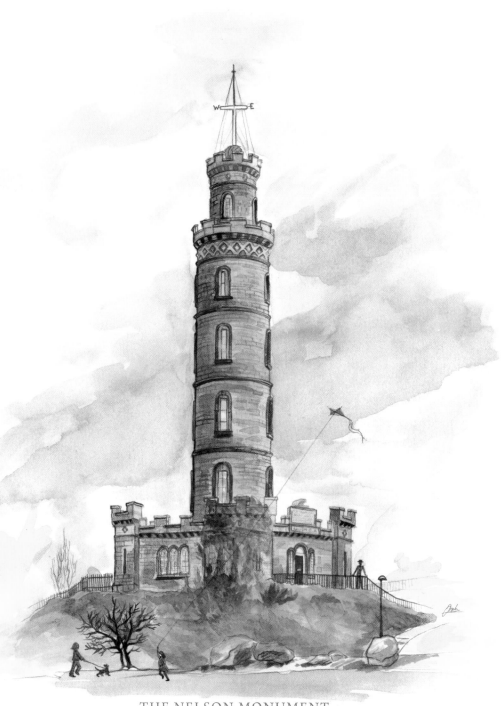

THE CITY OBSERVATORY

THE NELSON MONUMENT

Regent Road

Princes Street extends eastwards to Waterloo Place and Regent Road, which contains St Andrew's House, built in the 1930s as the administrative headquarters of the Scottish Government and designed by Thomas Tait. It stands on the site of the old Calton Jail with 'brooding authority' looking over the East End of the city, and was the largest metal framed building in Europe at that time.

Just across the road is the fine old Royal High School building, empty and, at the time of writing, still looking for a proper role since the school moved to north Edinburgh in the 1940s. It was potentially the home of the new Scottish Parliament, and there has been a battle of different proposals to restore the building to its former glory as the 'noblest monument of the Scottish Greek Revival', and the 'single building which most justified Edinburgh's epithet Athens of the North'.

THE SCOTTISH GOVERNMENT OFFICE

St Andrew's House is the Art Deco headquarters of the Scottish Government. From the south side across the Waverley valley, it looks imposing and dramatically irregular, though rather more restrained from Regent Road. The former Royal High School can be seen at the far right.

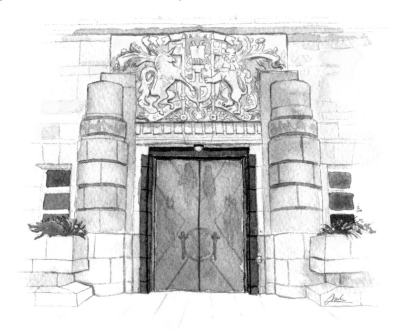

THE SCOTTISH GOVERNMENT OFFICE DOORWAY

The magnificent bronze front entrance depicts four Scottish saints around a St Andrew's Cross – Ninian, Columba, Kentigern and Magnus.

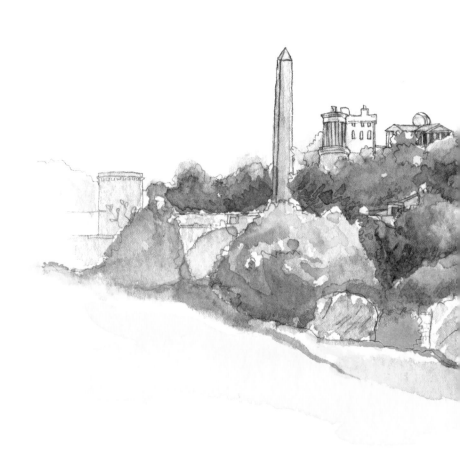

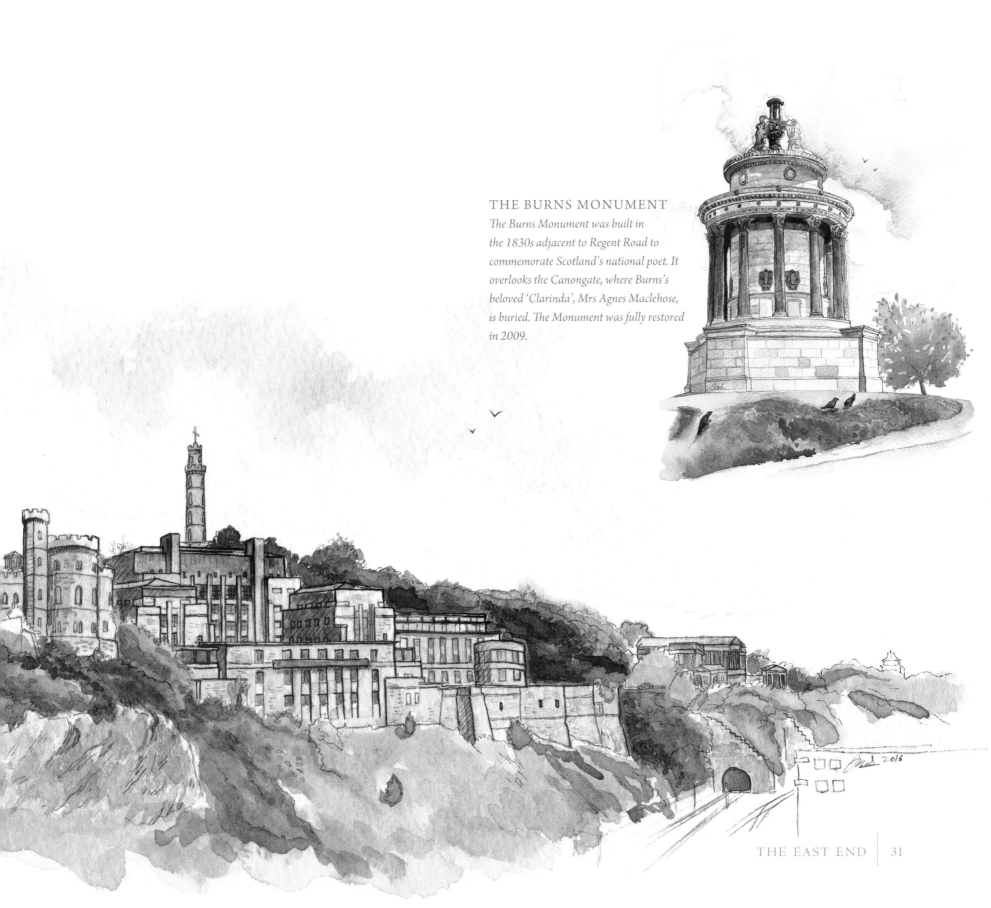

THE BURNS MONUMENT

The Burns Monument was built in the 1830s adjacent to Regent Road to commemorate Scotland's national poet. It overlooks the Canongate, where Burns's beloved 'Clarinda', Mrs Agnes Maclehose, is buried. The Monument was fully restored in 2009.

East New Town

The success of the New Town led to an extension eastwards, first of all around the area of Broughton Street, East London Street and Gayfield Square, then around the east and south sides of Calton Hill. Demonstrating early nineteenth-century confidence in late New Town development, Regent Terrace, Carlton Terrace and Royal Terrace by William Playfair exemplify fine Georgian architecture. These elegant terraces form a long row curving round the base of Calton Hill facing the Canongate, Arthur's Seat and Holyroodhouse.

ROYAL TERRACE

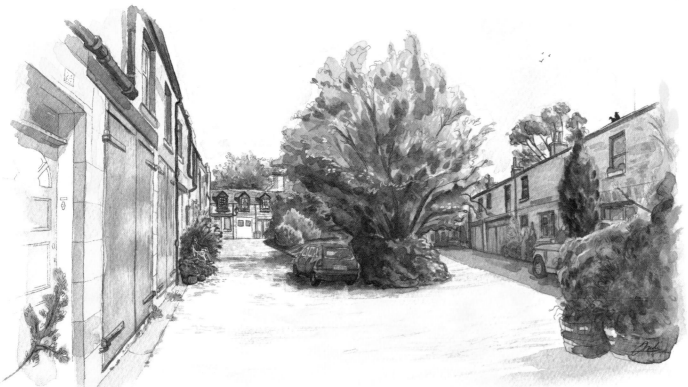

CARLTON TERRACE MEWS

The mews behind Carlton Terrace is a pretty 'village green' cobbled area, one of Edinburgh's hidden secret streets. Built in the 1830s, the cottages had living quarters on the upper floors and accommodation for the horses and carriages on the ground level, ready to serve their grand masters in the terraces next door.

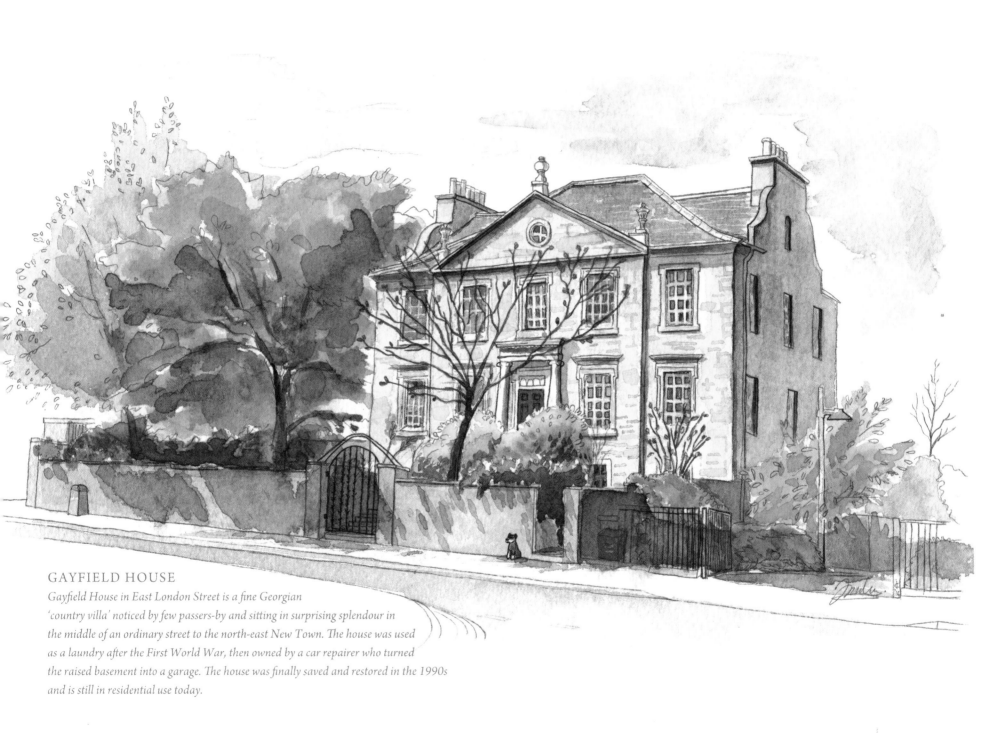

GAYFIELD HOUSE

*Gayfield House in East London Street is a fine Georgian
'country villa' noticed by few passers-by and sitting in surprising splendour in
the middle of an ordinary street to the north-east New Town. The house was used
as a laundry after the First World War, then owned by a car repairer who turned
the raised basement into a garage. The house was finally saved and restored in the 1990s
and is still in residential use today.*

THE NORTHERN NEW TOWN

Wide and elegant avenues of apartments, shops and businesses lead the visitor gently downhill from the city centre to the area known as the northern, or second, New Town. It was the next great stage in the development of the city in the early nineteenth century after the original New Town. Hanover Street in the centre of the original New Town becomes Dundas Street north of Queen Street and forms the main spine. Many of the streets in this area were named to celebrate significant military and political personnel and the battles they fought to save and form the early United Kingdom – Howe, St Vincent, Northumberland, Cumberland, Dundas, Pitt, Abercrombie, Nelson, Cornwallis and Dundonald. Frederick Street, further west, runs parallel to Hanover Street and leads downhill to Howe Street with St Stephen's Church at the foot, no longer an active place of worship. This unusual church with an outsized tower marks the eastern route into the former village of Stockbridge. Next door to the church is the charming St Vincent's Chapel, built in the 1850s, and nearby is the pub of the same name, often referred to locally as 'The Vinnie'.

Branching off Howe Street are the cobbled, leafy crescents of Royal Circus, with Circus Lane behind. Designed by William Playfair in 1820, these pretty crescents have private gardens in the middle – 'no ball games allowed'! On the corner of Circus Place and Howe Street is the Doubtfire Gallery, named after its former eccentric owner Madame Doubtfire, who was the inspiration for Anne Fine's children's book and the film *Mrs Doubtfire*.

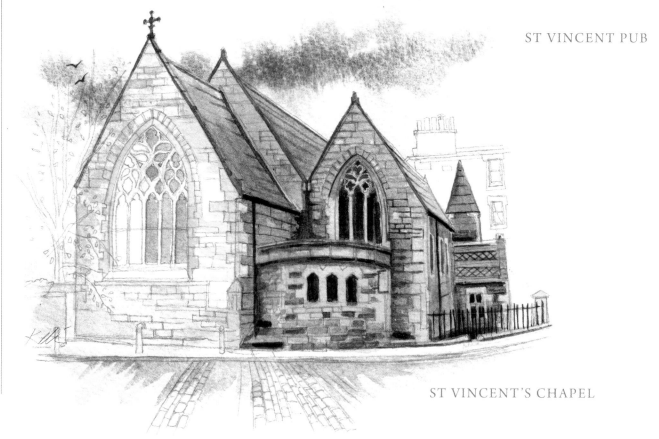

ST VINCENT'S CHAPEL

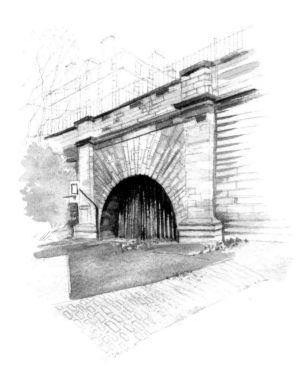

SCOTLAND STREET TUNNEL

At the east end of the northern New Town is the mysterious Scotland Street Tunnel. Opened in 1847 at the end of George V Park, it once encompassed an underground rail link to Waverley Station: the other end of the tunnel can still be seen opposite platform 19. A mile long, with a gradient of 1 in 27, the tunnel was so steep that it needed an engine to cable-haul the trains up the slope. Given the gradient, the tunnel seems an incredible achievement. George V Park itself once featured a huge roundabout called the Giant Sea Serpent set in a circular pond, in which fun-seekers frantically rowed in a 6-foot wide 'boat' tethered to the centre, with room for 600 rowers!

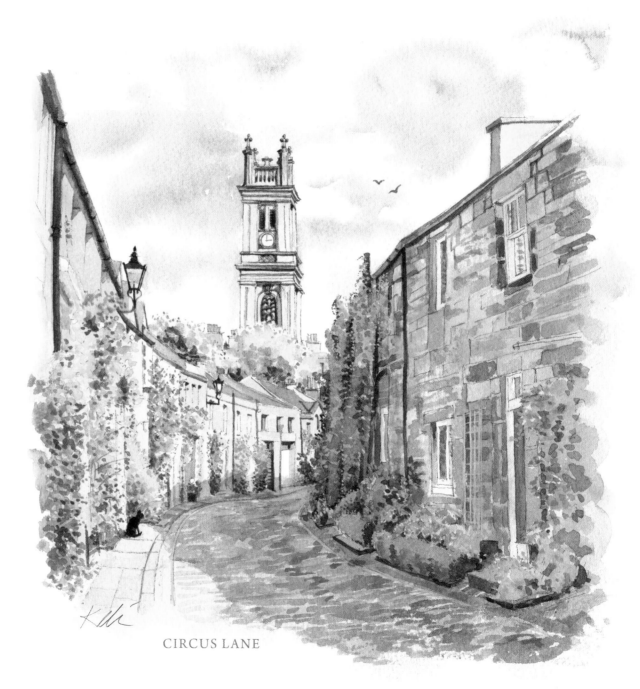

CIRCUS LANE

Stockbridge

Almost a village within the city, sometimes known as the New Town Village, Stockbridge is regularly voted one of the best places to live in Scotland. It can be reached by travelling down Howe Street through Royal Circus, to a bridge over the Water of Leith. This was originally the 'stock bridge', where cattle were driven across the bridge over the river below. Beyond the bridge is Deanhaugh Street leading to Raeburn Place, the heart of Stockbridge, a bustling thoroughfare hosting an eclectic collection of independent restaurants, coffee shops, butchers, bakers, fishmongers and charity shops. It is a bohemian hub with a tangible community spirit and a lively vibe.

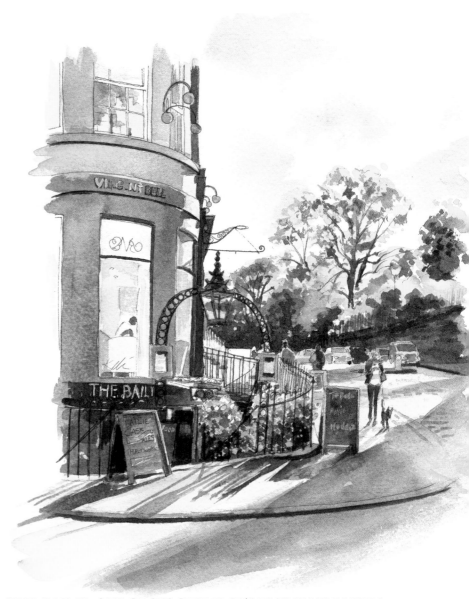

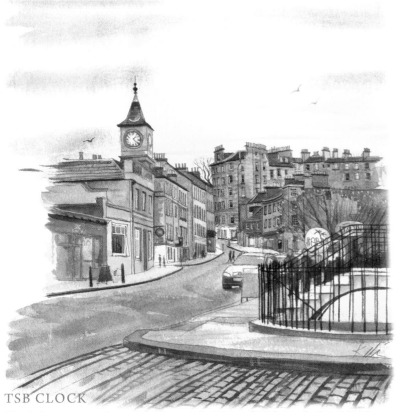

TSB CLOCK

The clock tower, near the main bridge over the Water of Leith, was built in 1900 by McGibbon and Ross. It was originally part of a bank, which is now a pizza restaurant.

THE BAILIE, ONE OF STOCKBRIDGE'S BEST-KNOWN PUBS

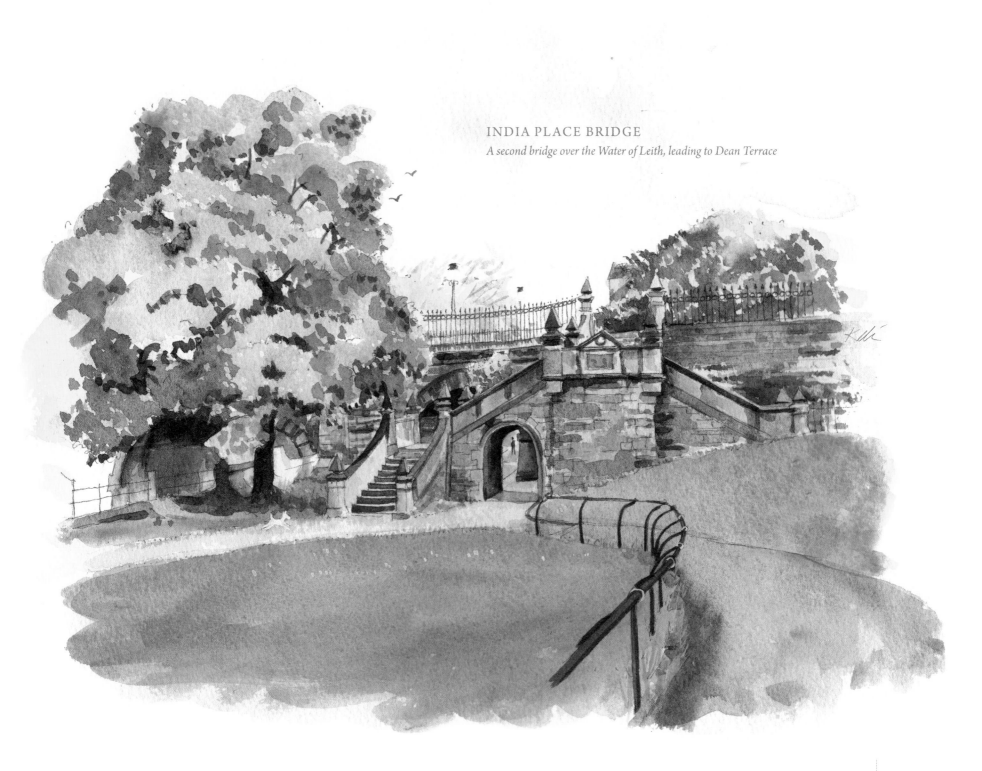

INDIA PLACE BRIDGE

A second bridge over the Water of Leith, leading to Dean Terrace

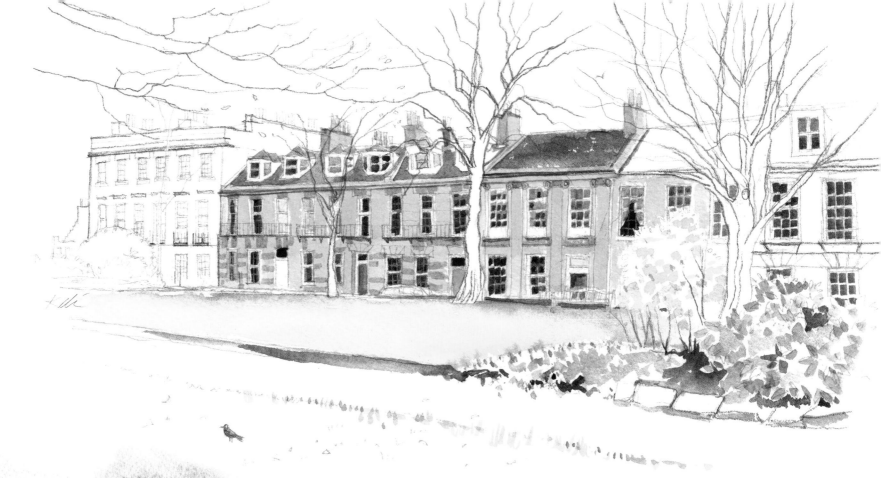

SAXE-COBURG PLACE WITH ITS CENTRAL GARDENS

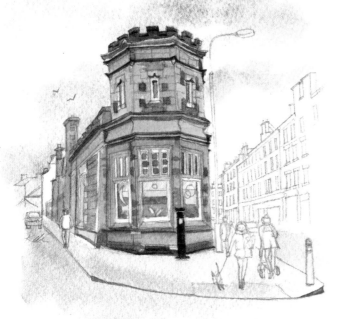

Towards the west of Stockbridge, leading off Dean Terrace, is Ann Street, designed by the Scottish portrait painter Sir Henry Raeburn and named after his wife. It was built in the 1820s, and along with St Bernard's Crescent and Saxe-Coburg Place (also in Stockbridge), these three are among the most beautiful residential streets in Edinburgh. They share a characteristic that is typical of Edinburgh in that they are intermingled with middle-class, working-class and sheltered housing developments, helping create the character and charm of the village of Stockbridge.

STOCKBRIDGE LIBRARY, HAMILTON PLACE

Smaller homes can be found in the eleven parallel narrow terraces that make up the Stockbridge Colonies, running perpendicular to the Water of Leith on the north side of Stockbridge. Built between 1861 and 1911 as a pioneering cooperative housing scheme, they provided affordable housing for the tradesmen and masons of the town. The streets are named after the company's founders, and the end house of each terrace displays a carving of the tools or coats of arms of the working people who resided there.

THE STOCKBRIDGE COLONIES

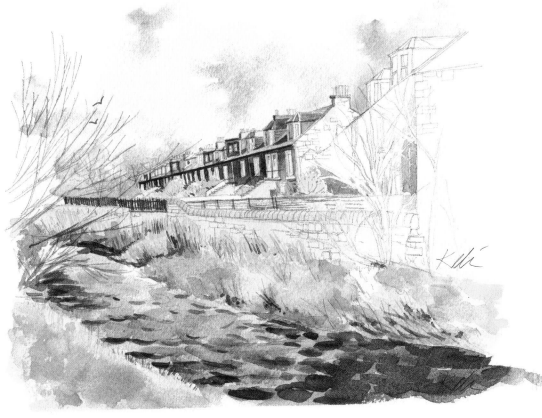

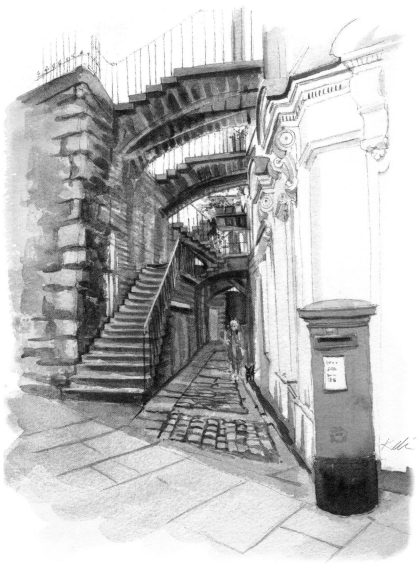

SECRET STEPS LEADING UP TO INDIA STREET

HEADING NORTH

There are several routes leading to the north of the city. At the western end of the New Town, Queensferry Road heads north-west over the Dean Bridge, through Learmonth, Ravelston and on to South Queensferry. Inverleith Row runs from the eastern end of the New Town past the Botanic Gardens and Warriston to Inverleith.

Heading outwards on Queensferry Road, just beyond the area of Learmonth, is a large Gothic Victorian building, which houses Stewart's Melville College, formed in 1972 by merging Melville College and Daniel Stewart's College. Combined with the Mary Erskine School it forms ESMS (Erskine Stewart's Melville Schools) and is one of two Merchant Company schools in Edinburgh.

Following the Water of Leith westwards beyond the Dean Village are the two Galleries of Modern Art, rather unimaginatively named Modern One and Modern Two. They face each other across Belford Road, part of the original high road north to Queensferry. Nestling close to the Galleries of Modern Art are two historically important Victorian cemeteries, the Dean Cemetery and its later extension. They contain a rich collection of memorials to some of the great and good of Edinburgh. These are peaceful and evocative resting places to wander round, and include lines of graves of famous Scottish judges, known locally as the Law Lords' Rows. Among those resting in this cemetery are Scottish artists William Allan, Robert Alexander, Samuel Peploe and John Bellany, surgeon William Bell of Conan Doyle fame, dictionary publisher Robert Chambers, intrepid traveller Isabella Bird, the architect William Playfair, Victorian photographer David Octavius Hill, and Elsie Inglis, female doctor and First World War heroine.

Further west is Ravelston Gardens, a development of three white Art Deco blocks of flats, known locally as the 'Jenners flats' because their original 1930s managing agent was the Jenners department store. They look rather like a cruise ship 'in full sail' and were radical for their time, with roof gardens, canopies, curved garages and separate stairs at the back for servants and delivery boys.

RAVELSTON GARDENS: THE 'JENNERS FLATS'

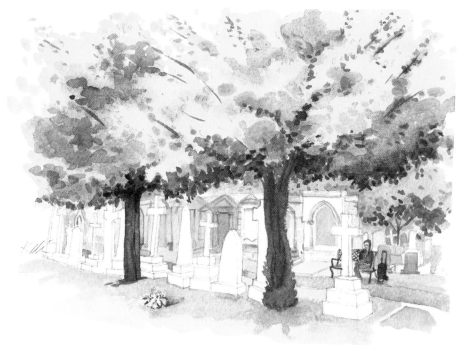

THE DEAN CEMETERY

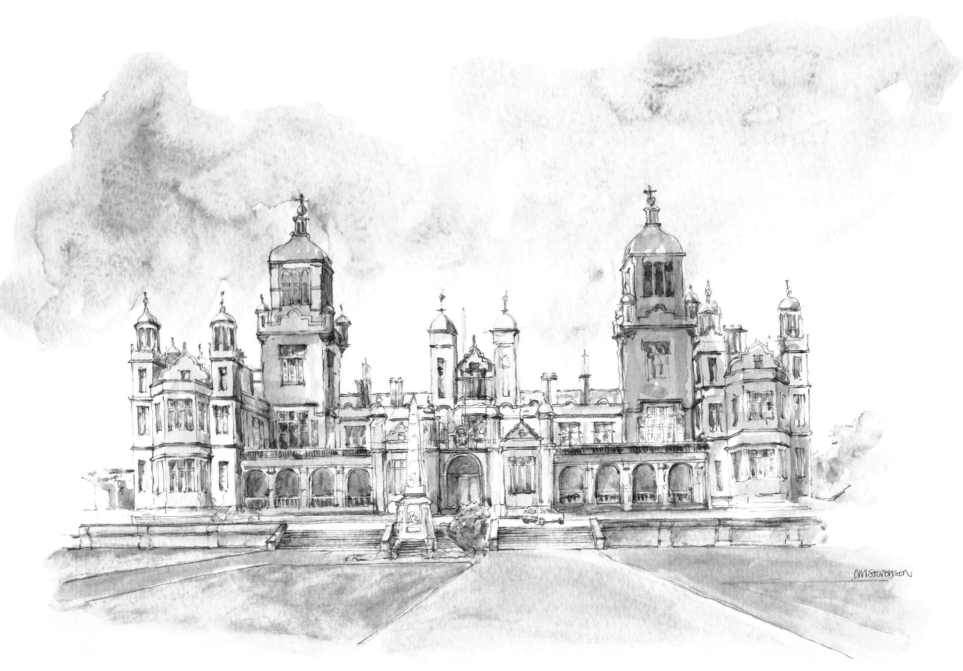

STEWART'S MELVILLE COLLEGE, QUEENSFERRY ROAD

Charles McKean described this as 'one of Edinburgh's most splendid pauper palaces, its magical skyline
combining Scottish Renaissance with English Jacobean'. It was designed by David Rhind and built in 1848.

The Dean Bridge and Dean Village

The Dean Bridge, designed by Thomas Telford and built in 1832, sits on four tall arches over the Water of Leith taking Edinburgh traffic out of the city towards the north-west. Deanbrae House, or Kirkbrae House, clings precariously to the precipitous edge of the southern end of the Dean Bridge. Parts of it date from the mid seventeenth century but every style has its place in this extraordinary seven-storey dwelling: Gothic, Arts and Crafts, classical revival, Tudor, Jacobean and 'toy town baronial'. Once owned for 60 years by a famous cab-hire entrepreneur named 'Cabbie Stewart', the house is still in private hands.

The Dean Village, ten minutes' walk from the West End, is a tranquil jumble of old buildings around a weir on the Water of Leith west of the Dean Bridge. In earlier times it was the centre of a milling industry, supplying Edinburgh with wheat flour for centuries. The barges came upriver from Leith to carry this trade, which seems extraordinary now, looking at the shallow waters of the river. Until the late nineteenth century the village was also known for its foul-smelling tanneries.

DEAN GARDENS

These privately owned gardens are on to the north bank of the Water of Leith, framed here by Thomas Telford's Dean Bridge.

THE DEAN VILLAGE

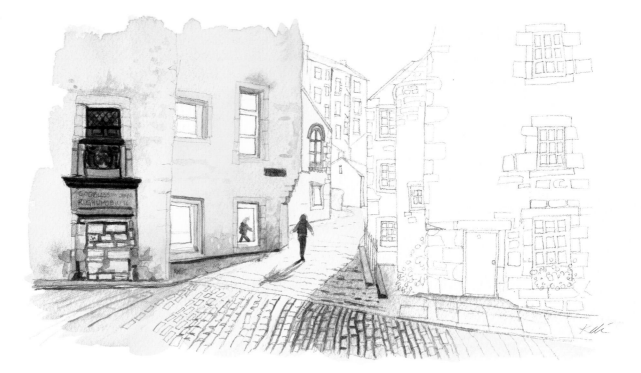

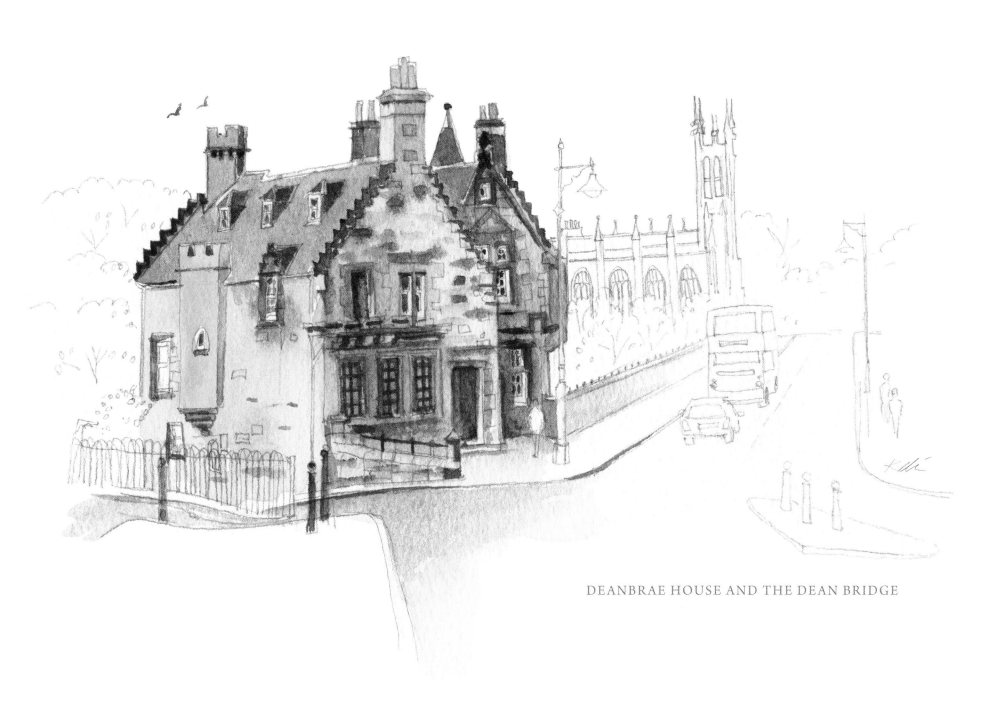

DEANBRAE HOUSE AND THE DEAN BRIDGE

Learmonth

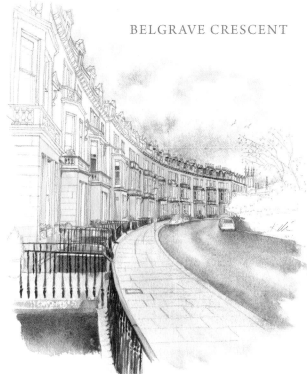

BELGRAVE CRESCENT

THE VIEW FROM ETON TERRACE TOWARDS RANDOLPH CLIFF

This famous Georgian terrace has been called 'a shotgun marriage between architecture and topography, towering above the 100 foot ravine down to the Water of Leith below'. The residents of Eton Terrace soak up the rear view of what is said to be the longest Georgian terrace in the world, from Randolph Cliff round to Doune Terrace.

DONALDSON'S

Formerly Donaldson's School for the Deaf, this is one of Edinburgh's four marvellously 'over the top' Gothic school buildings, the others being Heriots, Fettes, and Stewarts Melville. It is in the Wester Coates area not far from the Galleries of Modern Art. Completed in 1851, it was opened by Queen Victoria. Built in ornate European style, it has square towers, octagonal turrets, buttresses, tall chimneys and its own large chapel. After being empty for some years, it has been developed for residential use.

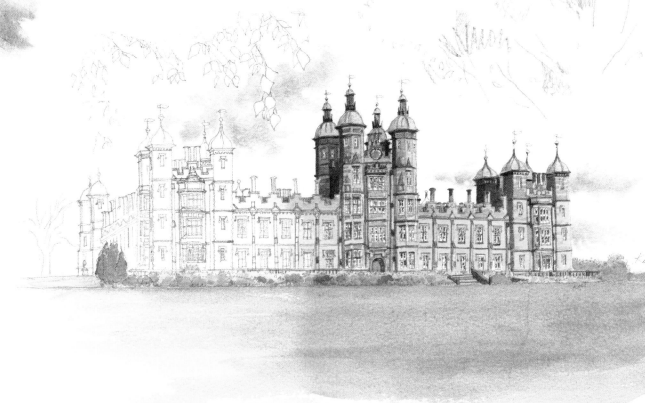

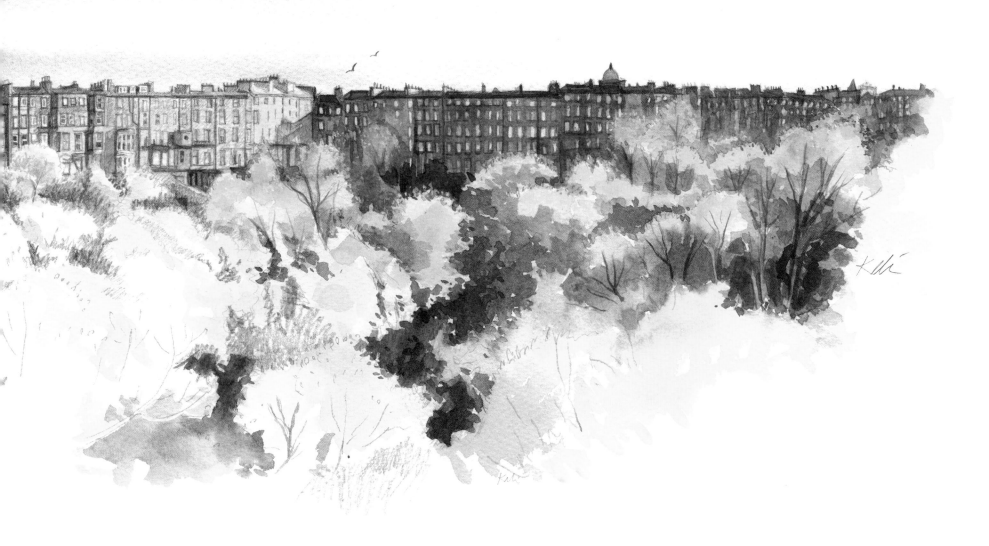

Beyond the Dean Bridge is the Learmonth area, built in the 1870s, described by McKean as 'long, opulent, if sedate, Victorian terraces . . . of confident large houses'. On the west, the elegantly curving Belgrave Crescent quietly surveys a private garden close to the city centre, while neighbouring Buckingham Terrace faces the highway to the north, Queensferry Road.

Across Queensferry Road to the east, Clarendon Crescent, Eton Terrace and Lennox Street border the edge of the Dean Gardens. Described by McKean as 'monumental terraces on the north cliff of the Water of Leith . . . New Town classical metamorphosed into richer Victorian', they were all built in the 1850s. The Dean Bridge straddles the steep gardens below.

The Galleries of Modern Art

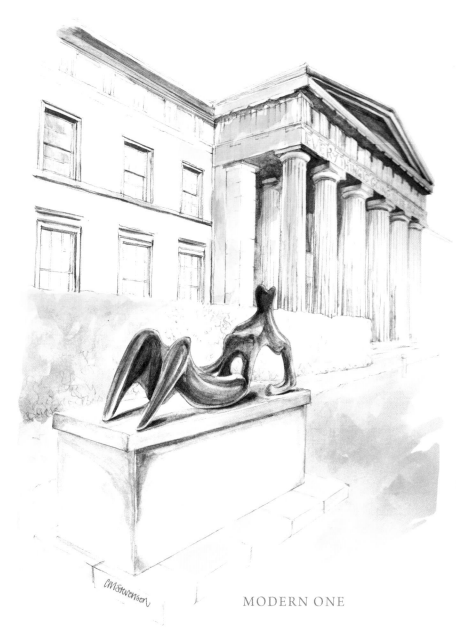

The Scottish National Gallery of Modern Art, on Belford Road, contains two buildings, Modern One and Modern Two. Modern One sits in undulating parkland, which acts as a natural backdrop to a collection of thought-provoking sculptures by artists such as Ian Hamilton Finlay, Henry Moore and Rachel Whiteread. Modern One originally opened in Inverleith House, in the Botanic Gardens, in 1960. It moved into its current home in 1984 and houses a wide portfolio of modern and contemporary art, including an impressive collection of works by Matisse, Picasso, and the Expressionists, Impressionists and Cubist artists. The neo-classical building was designed by William Burn in 1825 as a refuge for fatherless children, later becoming John Watson's Institution, a school for boys.

MODERN ONE

The lawn to the front of Modern One with landscape design by Charles Jenck

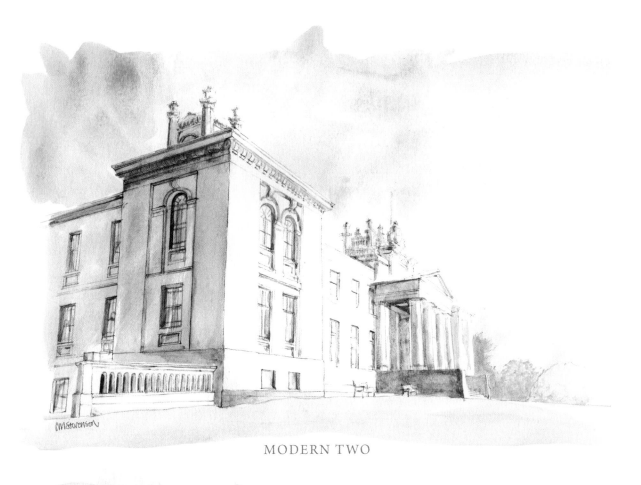

MODERN TWO

Modern Two, formerly the Dean Gallery, is also late Georgian and was designed by Thomas Hamilton as the Dean Orphans' Hospital, which opened in 1834. It was later converted to an education centre before transforming into the gallery in 1999. Modern Two houses the Gallery of Modern Art's permanent collection of Dada and Surrealist art and also holds visiting exhibitions of work. It pays homage to local sculptor Eduardo Paolozzi by including a reconstruction of his studio and his vast 'Vulcan' sculpture, which thoughtfully observes the visitors in the café enjoying their tea and cheese scones. There is a discreet gate into the Dean cemetery from the grounds.

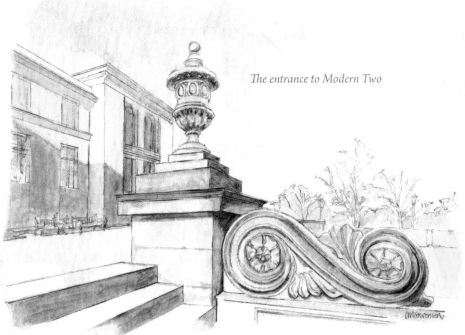

The entrance to Modern Two

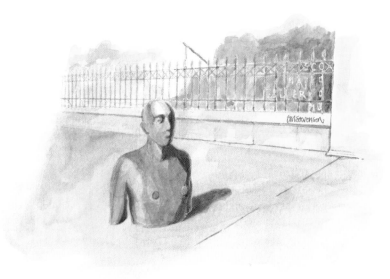

Antony Gormley's statue is partly consumed by the pavement.

Canonmills, Warriston and Inverleith

Lying in a hollow north of the New Town, the area of Canonmills was formerly a loch but was drained by 1865. It now hosts one of the main bridges over the Water of Leith, leading northwards onto Inverleith Row. The entrepreneurial Canons of Holyrood Abbey had operated a mill here since the twelfth century for the 'baxters' (bakers) of Canonmills and nearby Silvermills.

The area around Inverleith Row is mostly residential and recreational with commanding views of the Castle and city centre – a good place to view the Festival and New Year Fireworks. Of Inverleith Row itself, McKean says the buildings are 'grandiose columned classical villas' that 'clump uphill with Doric and Ionic-porticoed boots . . .'.

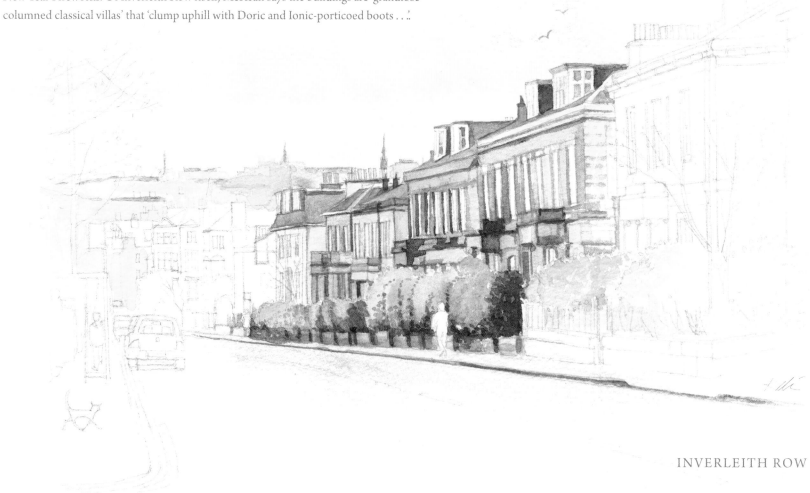

INVERLEITH ROW

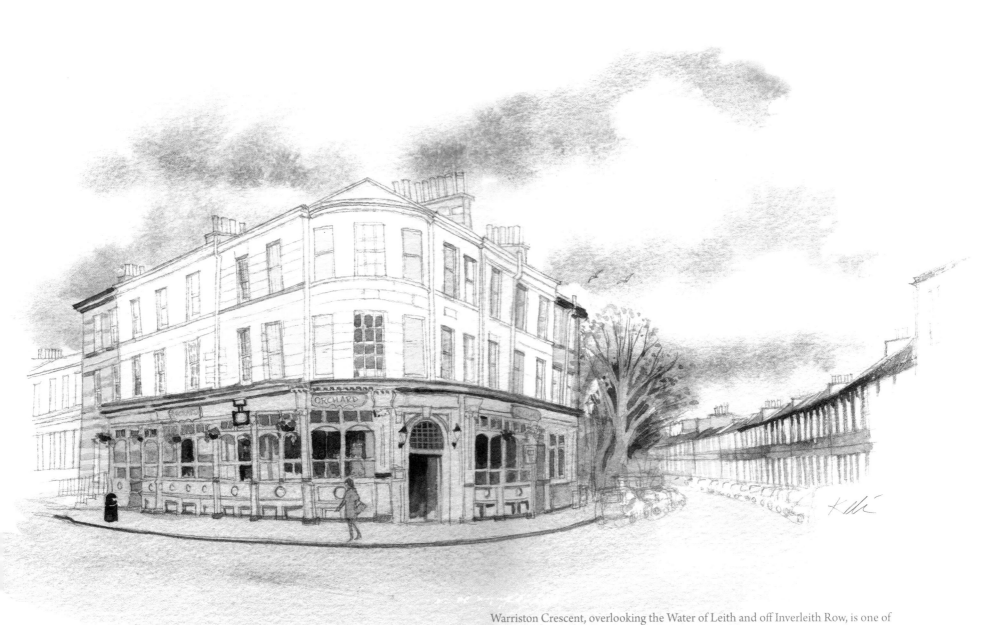

Warriston Crescent, overlooking the Water of Leith and off Inverleith Row, is one of the prettiest streets in Edinburgh (according to the granny of one of the authors!). Now that flood defences have been constructed, the gardens are a lot less soggy. Further north, towards Ferry Road, wide and elegant streets that sit between playing fields and the Botanic Gardens were completed in stages throughout the nineteenth century. They surround and adjoin the spacious Inverleith Park, founded by Edinburgh City Council in 1890.

WARRISTON CRESCENT

The Botanic Gardens

North of the New Town, on the west side of Inverleith Row are Edinburgh's Botanic Gardens or, to give them their proper title, the Royal Botanic Garden Edinburgh. They were originally formed in 1670 as a 'Physic Garden' to grow medicinal plants. The gardens have been located at various places in the city over the years: from Holyrood, to the 'Nor' Loch' (where Waverley Station now stands), to Leith Walk in 1763, and finally to their current 70 acre site in Inverleith in 1862. 'The Botanics', as they are affectionately known, are a tranquil space within the busy city. Running is 'strictly prohibited', although walking and indeed skipping are welcomed! The gardens are a world-renowned centre for plant science and education, whose mission is 'to explore, conserve and explain the world of plants for a better future'.

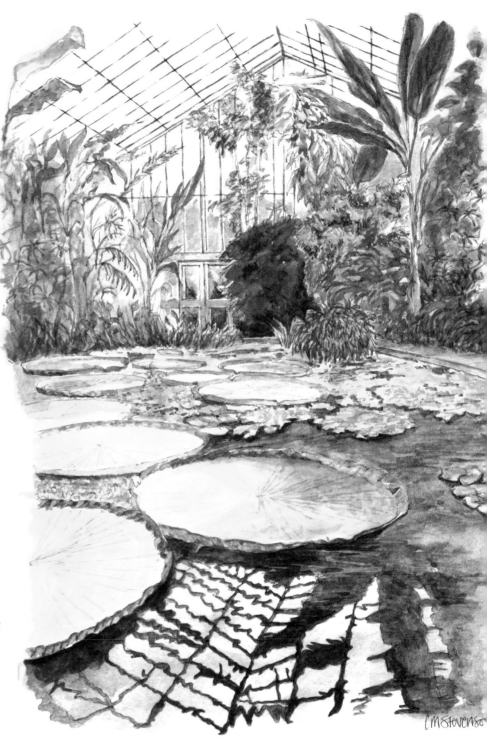

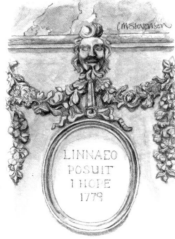

LINNAEUS MONUMENT
This urn (designed by Robert Adam and erected in 1779) commemorates Carl Linnaeus, the Swedish botanist who laid the foundation for the scientific classification of all living things, and who was a friend of the original Regius Keeper of the Gardens, John Hope.

ONE OF THE BOTANICS' PALM HOUSES
McKean describes 'the soaring iron and glass New Palm House, 1858, next to small octagonal Old Palm Stove, 1834, with splendid cast-iron spiral staircases cut into the stone'. A series of new connected glass houses was built in 1965.

The Gardens feature several imposing glass palm houses, a world-class Chinese terraced garden, a Scottish heath garden, a rock garden of alpine plants and a herbaceous border 165 metres long.

Nearly 300,000 individual plants, from 14,000 species – 4 per cent of the world's total species – are grown in Edinburgh and its three satellite gardens elsewhere in Scotland.

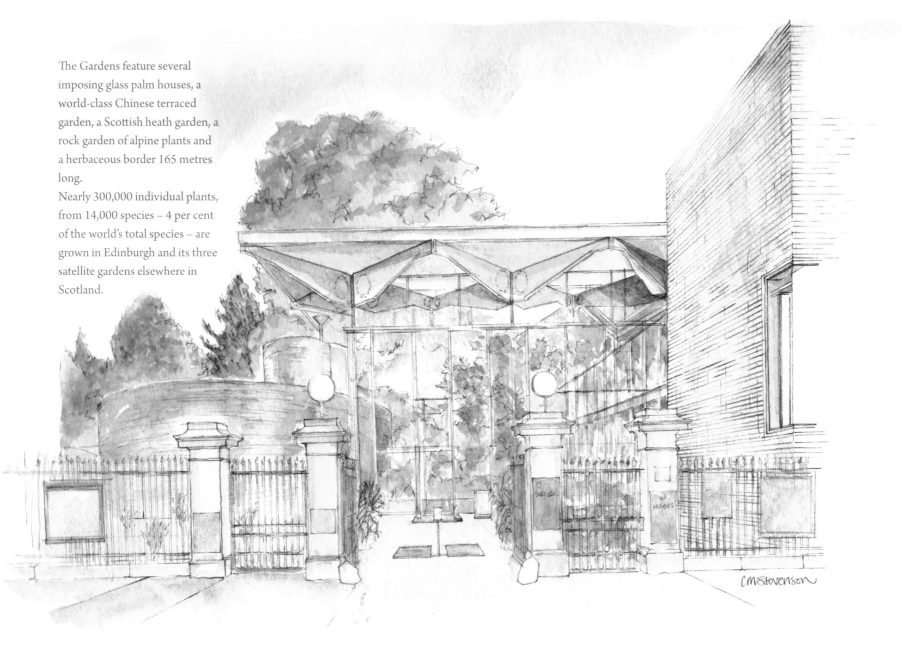

THE JOHN HOPE GATEWAY TO THE BOTANIC GARDENS

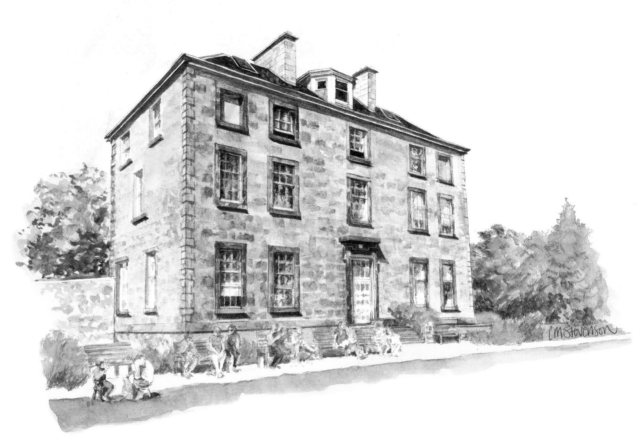

DETAIL OF THE EAST GATE

Made of electroplated stainless steel, the East, or Back, Gates on Inverleith Row were designed by Edinburgh architect Ben Tindall, completed by blacksmith Alex Dawson, and installed in early 1996. Their design is based on the beautiful pinky-white Rhododendron calophytum. They sit alongside and complement the earlier back gates, which also feature rhododendron motifs.

INVERLEITH HOUSE FROM THE NORTH

Inverleith House was built in 1774, and was lived in as a private house until the 1950s, when it was gifted to the Botanic Gardens. It is used as an exhibition space.

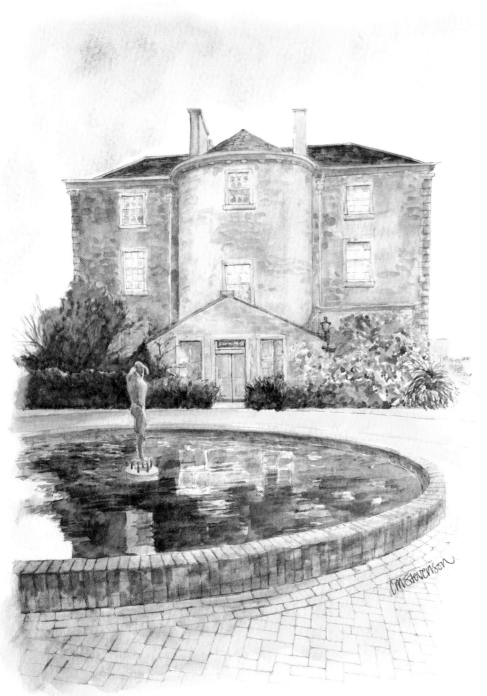

INVERLEITH HOUSE FROM THE SOUTH

The statue Girl, by British sculptor Reg Butler, is in front of the house.

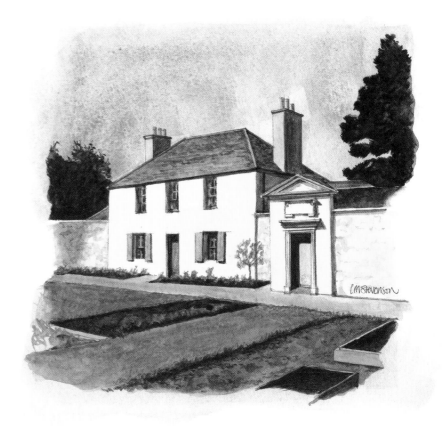

THE BOTANICS COTTAGE

This cottage was built in 1764–5 by the Regius Keeper John Hope, when the Gardens were in their site off Leith Walk. It was the head gardener's home, and housed a classroom for teaching botany to medical students. When the Gardens moved to Inverleith in 1820, the cottage was left behind. In 2015 it was finally moved, stone by stone, and rebuilt in its current location in the Botanic Garden.

HEADING SOUTH

The three main routes leading out to the south-east of the city are Dalkeith Road, Minto Street, and the old coaching route known as Causewayside, or 'Causeyside' from the old Scots word describing a 'properly paved or metalled road'.

The North Bridge leads from the east end of Princes Street over Waverley Station to the Royal Mile, straddling the Georgian New Town and the medieval Old Town. Located at the south end of the North Bridge is a handsome Edwardian building, completed in 1897, which for nearly a century housed the offices of the *Scotsman* newspaper. A spiral stone staircase outside leads directly down to Waverley Station, useful for newspaper distribution from the printing presses in the basement of the building. The building became a hotel in 2001 when the *Scotsman* moved to new premises.

Now almost entirely enclosed by buildings on both sides, the South Bridge is 1,000 feet long and does not resemble a bridge at all, until you gaze down to the Cowgate below from a gap between the buildings over one of the nineteen arches. Some of the vaults underneath the bridge have been restored and re-opened as tourist attractions for spooky walks.

The High School Yards area, around Drummond Street and Infirmary Street, to the east of the South Bridge, originally housed Blackfriars Monastery founded in 1230. Alexander Laing built the High School of Edinburgh on this site in 1770. Pupils included Sir Walter Scott and Professor James Pillans, who is credited with inventing the use of coloured chalk for use on blackboards for teaching. It remained the senior school in the city until the 'New' Royal High School moved to the site at Calton Hill. The building was then used as an extension of the Royal Infirmary, followed by the University's School of Geosciences and Geography and is now the Edinburgh Centre for Carbon Innovation.

THE OLD HIGH SCHOOL

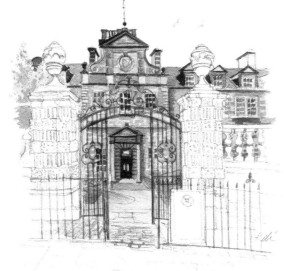

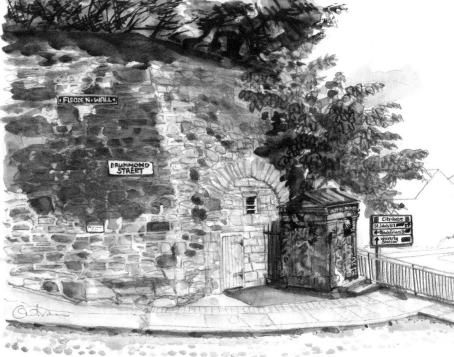

THE FLODDEN WALL

A wall defined the boundaries of the old city until the mid eighteenth century, and was expanded several times, particularly after the disastrous Battle of Flodden in 1513. The Flodden Wall enclosed roughly 140 acres, and a population of 10,000. It took 50 years to complete, but proved inadequate for effective defence on more than one occasion. It was used as much to control trade and disease – the plague – as for martial defence. Remains of the massive wall, up to 4 foot thick and 24 foot high in places, can still be seen near Greyfriars and Forrest Road, at the West Port off the Grassmarket and at the corner of Drummond Street and the Pleasance.

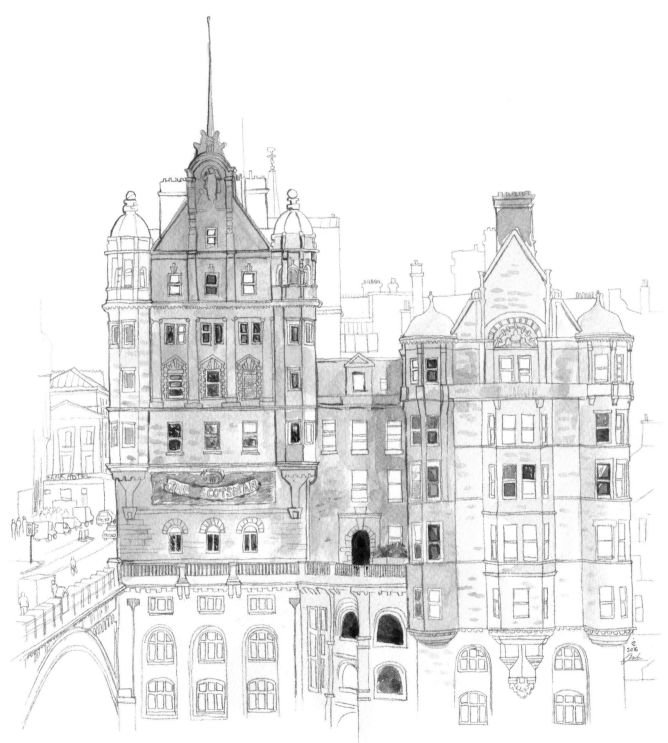

THE SCOTSMAN BUILDING ON NORTH BRIDGE

Old College and Nicolson Street

The South Side area is south of the Royal Mile and the Cowgate, taking in South Bridge and Nicolson Street on the east, and George Square and Edinburgh University towards the west. The Old College quadrangle is the heart of the University of Edinburgh at the southern end of South Bridge. It is of classical Georgian design, originally planned by Robert Adam in 1789 and then continued by William Playfair in 1827. The dome was finally added in 1870. The Old College houses University administration offices, the School of Law, the Talbot Rice Art Gallery, and the stunning 190 foot long Playfair Library, which is often quoted as the city's finest interior. The central courtyard was remodelled and refurbished between 2011 and 2013.

Just beyond the Old College is the Festival Theatre in Nicolson Street. It was originally built as the Empire Palace Theatre in 1928 with its interior a blend of Art Nouveau, Beaux Arts and neo-classicism. It was rebuilt and extended to form the Festival Theatre in 1994, and boasts an imposing glass frontage and an impressive 1,900 seat auditorium. Opposite the Festival Theatre is Surgeons' Hall, a 'Grande Dame' of a building designed by William Playfair.

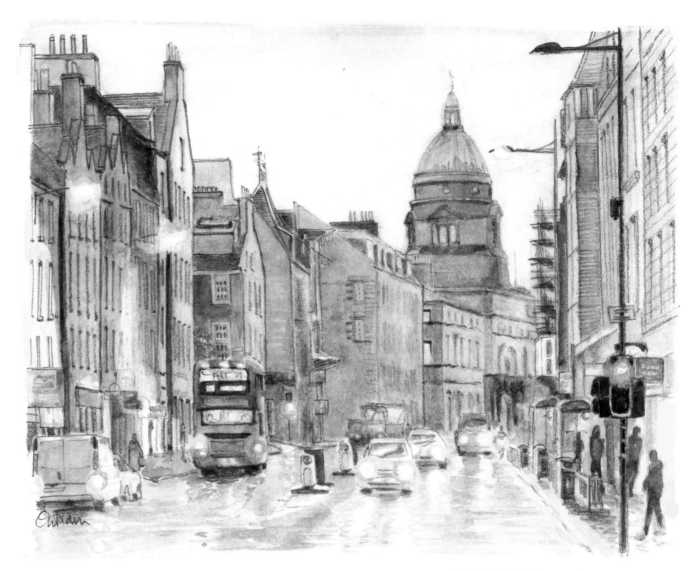

THE OLD COLLEGE

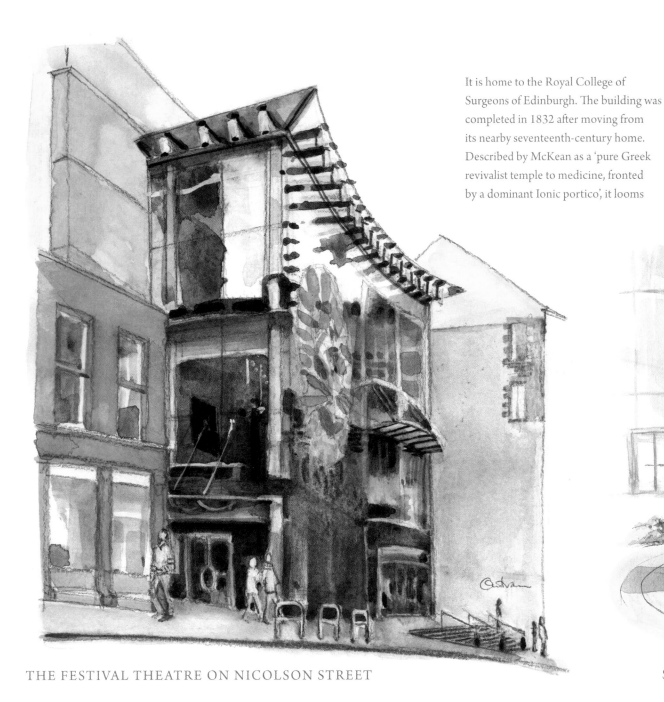

It is home to the Royal College of Surgeons of Edinburgh. The building was completed in 1832 after moving from its nearby seventeenth-century home. Described by McKean as a 'pure Greek revivalist temple to medicine, fronted by a dominant Ionic portico', it looms imposingly over the shops nearby. Behind the College is Hill Square, described by McKean as a 'tiny oasis of New Town gentrification on a scale which makes it almost possible to appreciate the real social qualities of a classical square'.

THE FESTIVAL THEATRE ON NICOLSON STREET

SURGEONS' HALL SCULPTURE

Chambers Street and Forrest Road

To the south-west of South Bridge lies Chambers Street, Forrest Road and Teviot Place. The National Museum of Scotland dominates Chambers Street. The original Royal Museum was designed by army engineer Francis Fowke and completed in 1861. At its centre is the Grand Gallery, a breathtakingly huge glass-roofed atrium rising four floors and 60 feet above the raised ground-floor area. The more modern Museum of Scotland was completed in 1998 and the two were unified in 2008. The much-loved museum boasts over 20,000 artefacts across 36 galleries and was re-opened in 2011 after a major refurbishment. Edinburgh Sheriff Court opposite the Museum of Scotland in Chambers Street was rebuilt in 1995. It also houses the Crown Office and Procurator Fiscal Service for Edinburgh. The building has eight floors stretching down to the Cowgate below, and is fronted at street level by huge bronze gates.

Edinburgh University's McEwan Hall on Teviot Place was financed by brewer William McEwan and designed by architect Sir Robert Anderson. It was built from 1888 to 1893, with the interior taking another three years, and final inauguration in 1897. This grand circular Italianate Renaissance building has been underused over the years – mainly for student graduations, occasional concerts and Festival events – but after some redesign and redecoration is extending its use as a conference and exhibition centre.

CHAMBERS STREET MUSEUM

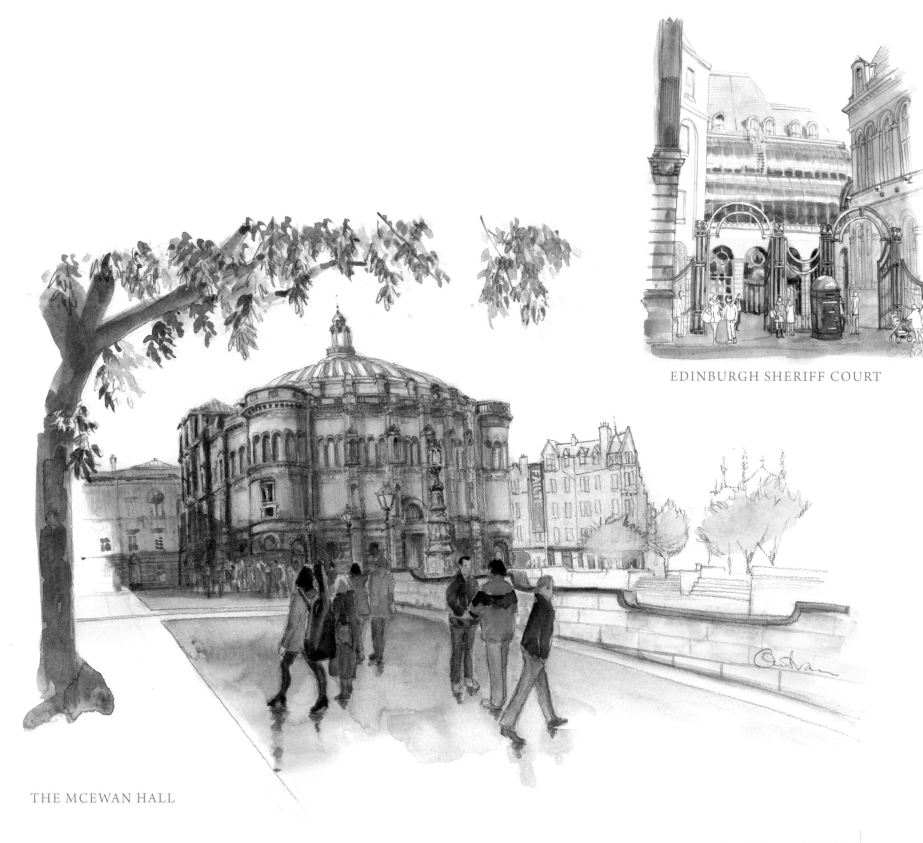

EDINBURGH SHERIFF COURT

THE MCEWAN HALL

George Square

George Square is regarded as Edinburgh's first real 'suburb' and first major residential development outside the Old Town. It was completed in 1763 (much earlier than the New Town to the north) as a classical square of elegant Georgian terraces. Its naming was apparently nothing to do with King George – the landowner, James Brown, decided to celebrate the name of his brother George!

Many of the buildings around the square were destroyed by Edinburgh University in the 1960s. In their place a series of buildings were erected to serve the University: Appleton Tower, David Hume Tower and Lecture Theatre, William Robertson Building, Basil Spence's University Library and later the Hugh Robson building. The Library is a deceptively spare building of almost Japanese elegance, often referred to by students as the 'Liquorice Allsort' for obvious black and white reasons. The elegant garden in the centre of George Square is a quiet oasis, and is open for students to supposedly work in, walk in, or to wander round the labyrinth. Until the twentieth century, sheep were regularly put out to graze in both George Square and the Meadows nearby!

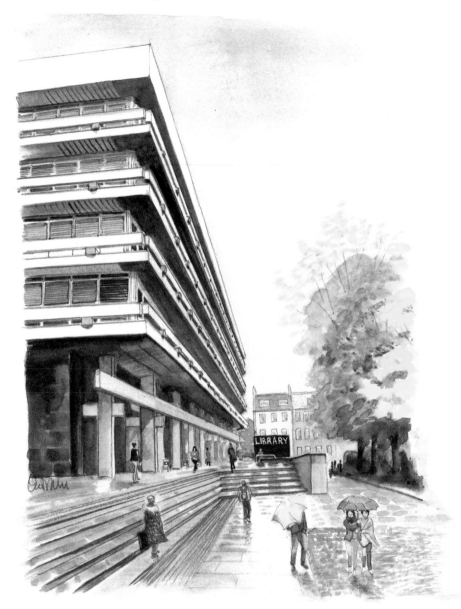

THE UNIVERSITY LIBRARY
Edinburgh University Library, designed by Basil Spence, is on the south side of George Square.

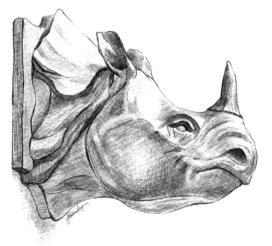

William Darrell's rhino head on the wall of the Informatics Building commemorates a similar head on the wall of Jim Haynes' famous bookshop in the 1960s. Haynes was one of the founders of the Traverse Theatre.

Part of George Square Gardens and the remaining Georgian terraces on the west side of the square

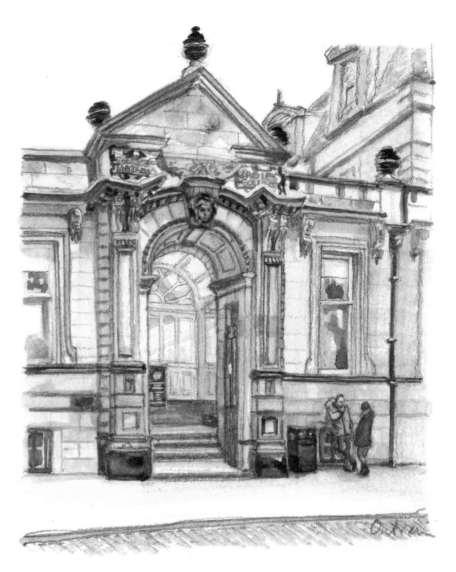

The plaque commemorating Charles Darwin's attendance at the University Medical School 1825–1827

7 GEORGE SQUARE

The former George Watson's Ladies College was opened in 1871 on the site of Admiral Duncan's House at 7 George Square. The school was formed to provide similar educational facilities for girls as the larger George Watson's Boys' College in Colinton Road. The two schools were amalgamated in 1974 and are owned and run by the Merchant Company. The building now houses the School of Philosophy, Psychology and Language Services of the University of Edinburgh.

The Meadows

The largest green space heading south from the city centre is the 60 acre area of parkland called the Meadows, south of Lauriston Place, erstwhile home of the old Royal Infirmary. Melville Drive runs along the southern edge of the Meadows, and Buccleuch Street and Buccleuch Place are to the east. This versatile public park is embraced throughout the year by students, families, runners and sports enthusiasts. There are sports pitches used for cricket in the summer and football in the winter, plus all-weather tennis courts, a children's playground – even a croquet club! The Meadows are criss-crossed by paths lined with cherry trees, blooming abundantly in April and May, scattering blossom across the grass and paths like confetti.

Middle Meadow Walk is the students' short cut from the student enclave of Marchmont to the University, and they can be seen scuttling across the Meadows on foot or bicycle.

The area was originally the Borough, or Burgh Loch, which was drained in the eighteenth and nineteenth centuries to create a public park. To the south-west it becomes Bruntsfield Links (originally the city's plague pit) which boasts a free pitch-and-putt golf course many centuries old.

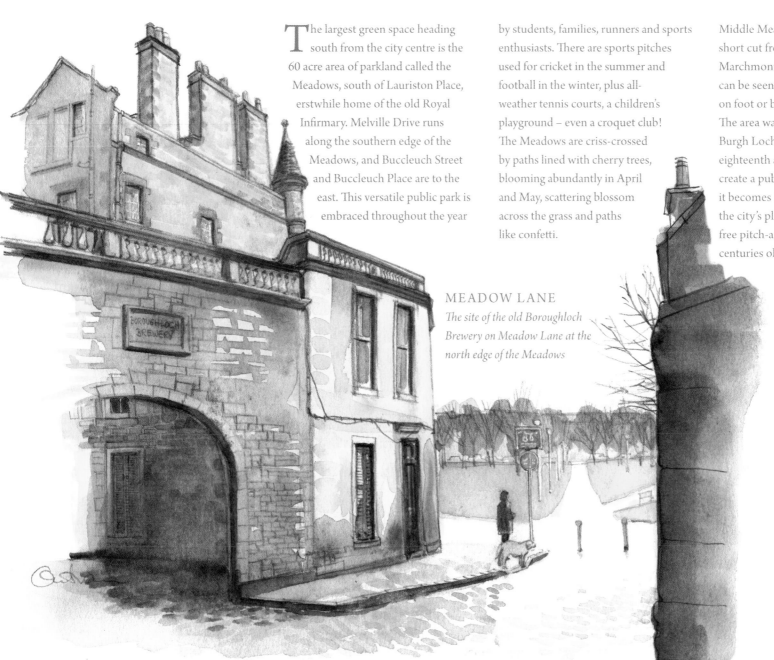

MEADOW LANE
The site of the old Boroughloch Brewery on Meadow Lane at the north edge of the Meadows

HOPE HOUSE

In Hope Park Square on the north side of the Meadows is a handsome harled villa, Hope House. It was built in 1770 and restored two hundred years later.

BUCCLEUCH STREET

On the eastern edge of the Meadows is Buccleuch Street, at the beginning of one of the principal ancient southern entrances to the city, Causewayside.

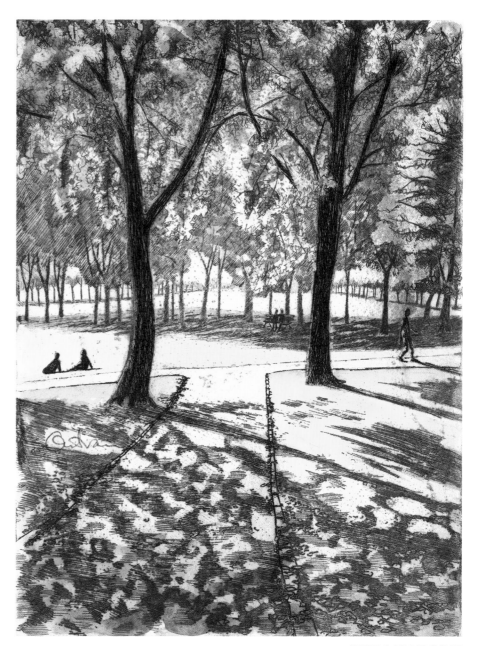

THE MEADOWS

The Pleasance, St Leonard's and Dalkeith Road

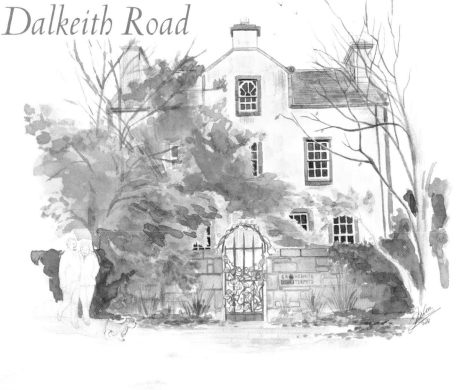

The Pleasance and St Leonard's Street, running alongside Arthur's Seat and Holyrood Park to the east, formed the ancient route into south-east Edinburgh from Dalkeith Road. This area contained some of Edinburgh's most notorious slums up to the mid twentieth century. The area is now transformed, and much safer, perhaps partly due to the location in the 1980s of the Central Division Police Headquarters in St Leonard's Street.

In the 1800s the area was home to the Edinburgh and Dalkeith Railway, which was closed when the North British Railway opened at Waverley Station. It was used as a coal yard until the early 1960s.

HERMITS AND TERMITS

This former 'country house' on St Leonard's Street dates from 1734. It was restored to its former glory by architect Ben Tindall in the 1980s. He regarded the project as an act of faith, as the St Leonards area was rather derelict at the time.

THE SCOTTISH WIDOWS BUILDING

The Dalkeith Road offices of Scottish Widows insurance company, which is part of the Lloyds Banking Group, were designed by Sir Basil Spence and opened in 1976. The brown glass building complex is made of interlocking hexagonal blocks of one to four storeys in height, designed to emulate the structure of the basalt rock of Salisbury Crags in the background.

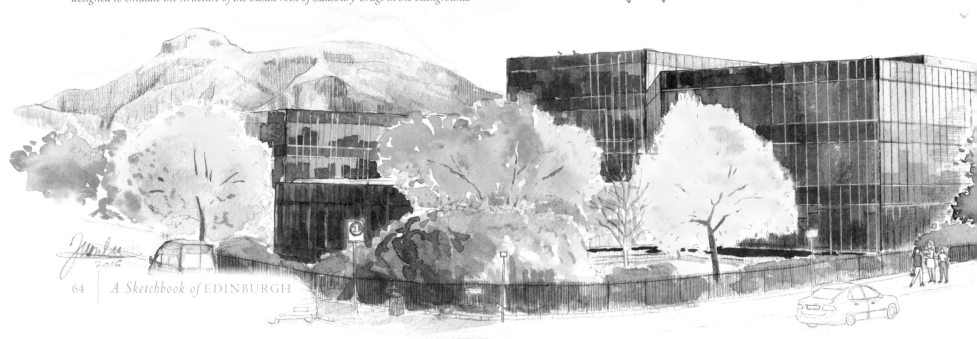

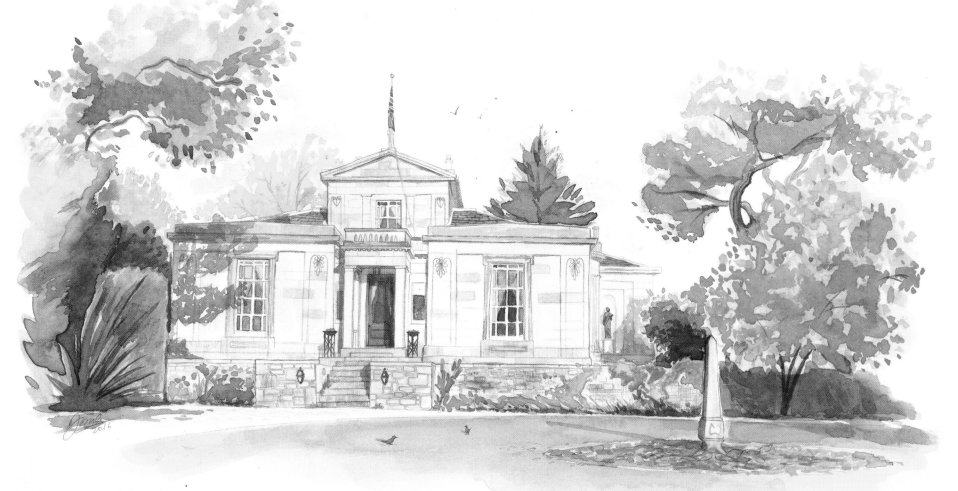

ARTHUR LODGE

Regarded as one of Edinburgh's finest homes of the Georgian era, Arthur Lodge on Dalkeith Road was built in 1829, on the outskirts of the city. It was beautifully restored in 1985 and again in 2003. The house is attributed to architect Thomas Hamilton, designer of the Dean Gallery, the Burns Monument and the old Royal High School. The beautiful symmetry of the front belies an intriguing internal layout, because no two rooms have the same floor and ceiling levels!

THE ROYAL COMMONWEALTH POOL

This swimming pool was built for the 1970 Commonwealth Games, and is described by McKean as 'floating in clean horizontal lines against the backdrop of Arthur's Seat'. It underwent full restoration in 2012 and is a centre for watersports excellence.

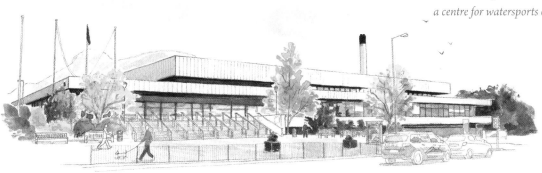

Bibliography

Robert Chambers, *Traditions of Edinburgh*, W & R Chambers, 1996 (first published 1868)

Hamish Coghill, *Lost Edinburgh*, Birlinn, 2008

Stuart Harris, *The Place Names of Edinburgh*, Steve Savage Publications, 2002

Arthur Herman, *The Scottish Enlightenment: The Scot's Invention of the Modern World*, Fourth Estate, 2001

Insight Guide: Edinburgh, APA Publications, 2002

Charles McKean, *Edinburgh: An Illustrated Architectural Guide*, Royal Incorporation of Architects in Scotland, 1992

Victoria MacLeay, *Immigration since 1788: The Making of Modern Australia*, Trocadero, 2011

Alistair Moffat, *Scotland: A History from Earliest Times*, Birlinn, 2015

Hannah Robinson, *Secret Edinburgh: An Unusual Guide*, Jonglez, 2016

Sir Daniel Wilson, *Memorial of Edinburgh in Olden Times*, Cambridge University Press 2013 (first published 1848)

EXTRACTS QUOTED IN THE BOOK

We have used a number of quotations in the text and captions, and acknowledge these sources here, with thanks to those who gave us permission to use them. Most of the quotations are from Charles McKean's wonderful book *Edinburgh: An Illustrated Architectural Guide*. Quotations on page ix are from *Insight Guide: Edinburgh*. Quotations on pages 42 and 44 are from Hamish Scott, 'An eccentric's invitation to the mad house', *The Telegraph*, 6 July 2002.

Acknowledgements

We are grateful to the following:

The four talented artists, Irina Cucu, Cat Outram, Keli Clark, Catherine Stevenson, for their wonderful illustrations, and Irina Cucu particularly, for her design work on the layouts

Alexander McCall Smith for general friendly advice and support, and the Foreword!

Our publisher Birlinn, for . . . so much

Our friend Stana Nenadic, Professor of Social History and Cultural History, University of Edinburgh, for comments on an early draft and general support

My business partner David Taylor, and all the staff of The Elephant House

Stuart Brown and George Leslie for encouragement, and useful introductions!

Jonathan and Rachel Callaway, for proofreading and general friendliness

Staff of Costa Coffee, Raeburn Place, Stockbridge; Mae Douglas of The Write Stuff; and Cecile Copier and Lydia Copier of L'Echoppe Café, for long, helpful Wednesday and Friday mornings

Bridget and Geoffrey Lockyer, for happy cousinly friendliness and support

Jimmy and Bev Craig, again for cousinly friendliness and book sourcing

Our good friends Adam More and John Scott Moncrieff, wise men, again for guidance and support

Ben and Jilly Tindall, and Alan and Elizabeth Brown, for graciously allowing us to produce illustrations of their homes

Chic Husband and Ron Hourston, again for friendship and proofreading

Duncan James Fraser and Isla Haze Waiwai, for keeping us grounded and sane.

Artists' Biographies

KELI CLARK is a self-taught artist living in the Scottish Borders. Her work and style are quite diverse, ranging from Scottish landscapes, Edinburgh cityscapes, mystical and imagined themes to wildlife, hares in particular. She works in all mediums, with influences from nature, night-time walks, music and the phases of the moon. Keli's work is well known in and around Edinburgh, the Lothians and Fife, and her work is in private collections in over twenty countries around the world.

IRINA CUCU was born in Bucharest, Romania; with the guidance of her Primary School art teacher, and her parents' support, she was accepted to the Nicolae Tonitza School of Art at the age of 10. Irina moved to Vienna to complete her secondary education, before being accepted to the Edinburgh College of Art, from where she graduated in 2015. She is now working as an illustrator and fine artist, based in Edinburgh.

CAT OUTRAM was born in Kenya, and emigrated with her family to the UK in 1966. She graduated with BA Honours from the Edinburgh College of Art in Drawing and Painting in 1981, and eventually registered as a professional printmaker in 1990. Cat is best known for her etchings, and she has exhibited widely in Edinburgh and throughout Scotland.

CATHERINE STEVENSON is an Edinburgh-based artist who studied Drawing and Painting at the Edinburgh College of Art, graduating in 1978. After a long teaching career, which included 28 years at George Watson's College in the city, she took early retirement to concentrate on her own work.

If you have suggestions for Edinburgh buildings or places that could appear in a second volume of this book, please get in touch: edinsketchbook@gmail.com

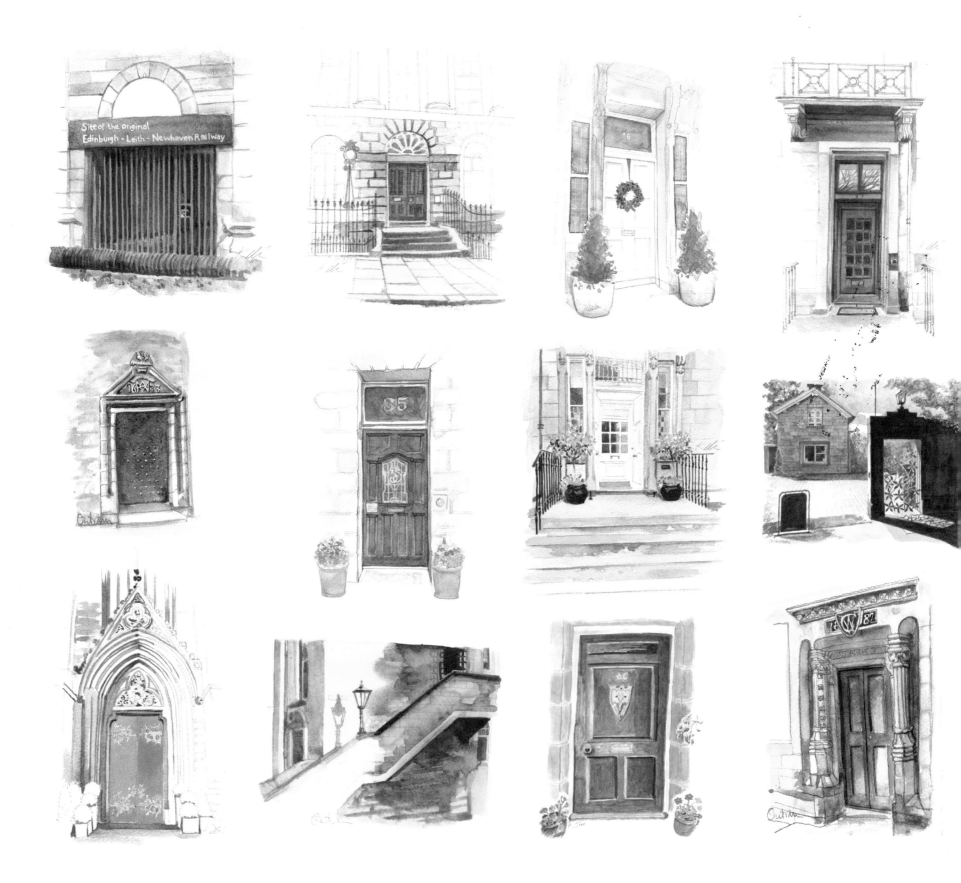